I am compelled to restate
and celebrate the Mysteries.

—Leo Kenney, 1968

Celebrating the Mysteries

LEO KENNEY
A RETROSPECTIVE

Foreword by Barbara Straker James
Essay by Sheila Farr

MUSEUM *of* NORTHWEST ART LA CONNER, WASHINGTON
in association with
UNIVERSITY OF WASHINGTON PRESS SEATTLE AND LONDON

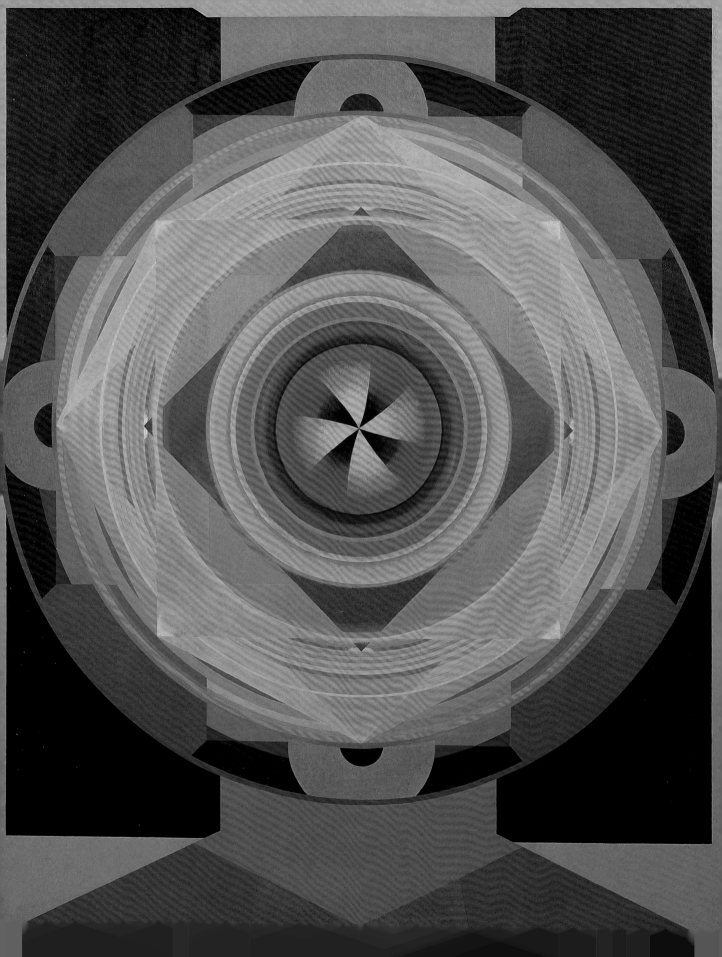

Celebrating the Mysteries was organized by the Museum of Northwest Art.

This publication accompanied an exhibition of the same title presented at the Museum of Northwest Art, June 2–October 1, 2000.

Published by the Museum of Northwest Art, La Conner, Washington, and the University of Washington Press, Seattle.

Front cover: *Seed and Beyond VIII*, 1981–82 (pl. 66)
Back cover: Leo Kenney, 1949
Frontispiece: *Communicator* (detail), 1965 (pl. 35)
Page 6: *Amaranth*, 1966 (pl. 39)
Page 10: *Island in Summer* (detail), 1976 (pl. 61)

Designed by John Hubbard
Edited by Jennifer Harris
Produced by Marquand Books, Inc., Seattle
Printed and bound by C&C Offset Printing Co., Ltd., Hong Kong

Library of Congress Cataloging-in-Publication Data
Kenney, Leo, 1925–

 Leo Kenney, a retrospective : celebrating the mysteries / foreword by Barbara Straker James ; essay by Sheila Farr.

 p. cm.

 Catalog of an exhibition held at the Museum of Northwest Art, June 2–Oct. 1, 2000.

 Includes bibliographical references.

 ISBN 0-295-97960-7 (cloth : alk. paper) —
ISBN 0-295-97961-5 (paper)

 1. Kenney, Leo, 1925—Exhibitions. I. Farr, Sheila. II. Museum of Northwest Art. III. Title.
ND1829.K46 A4 2000
759.133—dc21 00-25518

All reproduced artworks by Leo Kenney, except where noted. All measurements are in inches; height precedes width.

Photography credits:
Board of Trustees, National Gallery of Art, Washington, D.C., fig. 3; Tom Kelly, pls. 58, 67; Paul Macapia, figs. 1, 2; Frank Murphy, back cover, p. 24 (portrait), courtesy of Martin-Zambito Fine Art, Seattle; The Museum of Modern Art, New York, fig. 9; Richard Nicol, p. 6, pls. 4, 7, 11–13, 16, 17, 22, 26, 38, 39; Mary Randlett, figs. 7, 8; Jake Seniuk, pls. 14, 21, 23, 68; Rob Vinnedge, front cover, frontispiece, p. 10, pls. 1–3, 5, 6, 8–10, 15, 18–20, 24, 25, 27–37, 40–57, 59–66, 69–72

Contents

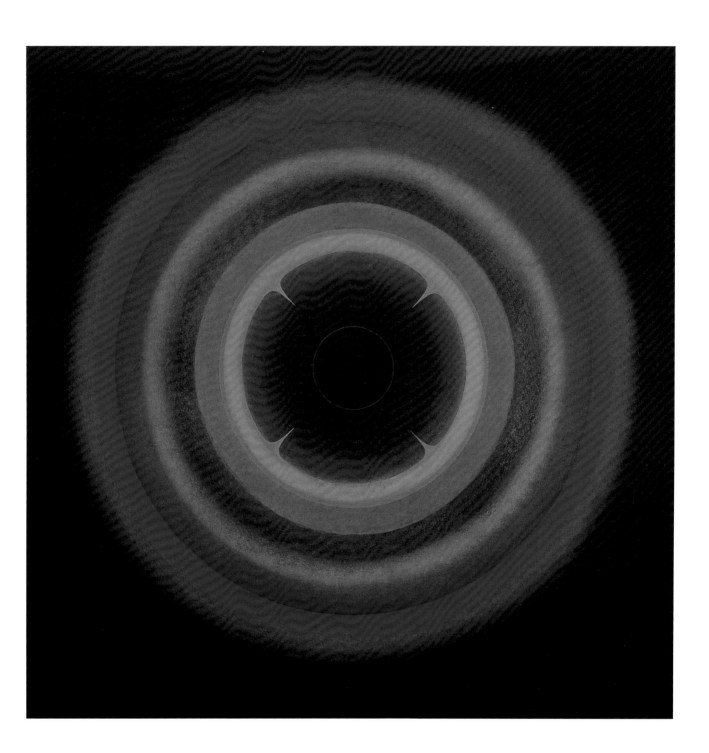

Acknowledgments

Putting together a major exhibition and catalog is never an easy task, and only through the dedication and assistance of many people is it possible. My thanks to Marshall Hatch for suggesting and supporting the project, Barbara Straker James for her inspired curatorial skills and practiced eye, Sheila Farr for her insightful essay, and Leo Kenney for sharing his work and his life. Merch Pease's careful chronicling and championing of Kenney's career made our job much easier. My gratitude is extended to Fred Poyner for his research and editorial assistance. We are also indebted to the many private and public lenders to the exhibition.

Support from the Paul Allen Foundation for the Arts, the Washington Women's Foundation, the Washington State Arts Commission, and generous donations from friends and the MoNA Board of Trustees allowed us to complete this project.

We are pleased and proud to *Celebrate the Mysteries* with Leo Kenney, Northwest Master.

SUSAN PARKE
Executive Director

Foreword

Leo Kenney was a teenage phenomenon
a young visionary with dreams of the supernatural and the surreal
a fascination with the symbolists
an admiration for de Chirico
he was eager to create new worlds
he loved invention and all kinds of symbols
he would start with some rocks and invent a universe to go with them
he loved cryptic images and the surrealist process of automatic drawing
Metamorphosis
Images
it made no difference that he did not know the precise meaning of a figure or a symbol
shape was more important to him than meaning
shape inescapably carried meaning

Shape became his expression—his modus vivendi
he pushed forward into squares, circles, rectangles
that became tondos, mandalas, universes, planets, worlds
mystic secrets were locked in their forms
the transcendent and cosmic came along for the ride
when forms were emptied of meaning, he redirected
he loved the free play of a painting, starting with no image, moving freely over the paper
he loved the energy of seeds
to begin from a center
to push out, expand, and explode into space

Inspired by Tobey and Graves, the influences were never a hindrance
empowered, he went beyond, took his painting to new levels

In a last great burst of energy before the body rebelled he produced the *Geometrics*—
a shower of triangles, hexagons, polygons, circles, and squares—*Flight over Red Cloud*
or *Stars in Red Weather*—dramatic displays swift as comets, they hastened to take
their place in some celestial order

Self-taught—he switched from oils and egg tempera to gouache—his technique required
the discipline of a Zen monk and a steady hand
his concentration was intense
his draftsmanship meticulous
his brushstrokes flawless
his compositions so finely calibrated a misplaced dot of color caused a jarring imbalance
he developed a mastery over Chinese papers
he knew how much pigment to put on the tip of a brush, when to blot, how it would dry
he might wait months or years before applying the final brushstrokes
waiting was part of the process, so was a trip to the bar
such dedication to perfection did not come without physical cost

His life has been a series of survivals
a hill and dale of exaltations and burnouts
of triumphs and exhaustions
of lying fallow and riding the crest—fueled by enthusiasms and visions, sustained by
persistence and intellect—he has arrived on the far shore of seventy-five secure in the
hierarchy of the visionaries
a mature artist, a master of the *cosmic presence*—a miraculous survivor

Around a Light II and *Lunar Moth* have become a coda for the physical price he has paid—
tender icons to the beauty, the fragility, and the utter tenuousness of life

BARBARA STRAKER JAMES
Curator

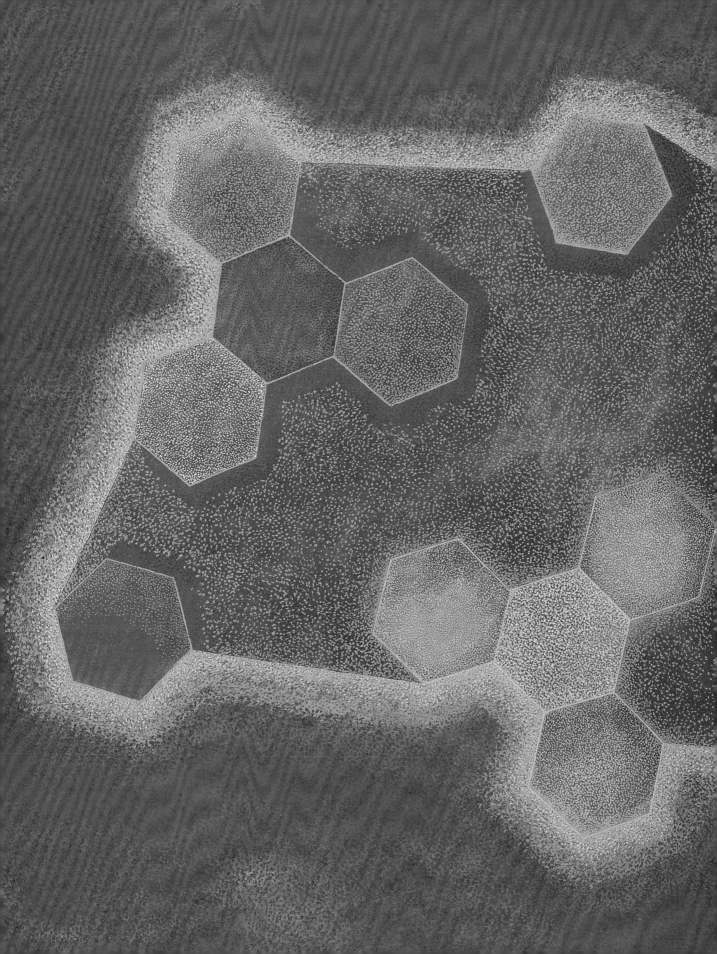

LEO KENNEY

by Sheila Farr

If any Northwest artist in 1973 seemed destined for great things, it was Leo Kenney. His Seattle Art Museum retrospective that year crowned a decade of success. A few years earlier, his first one-man show in New York had prompted a *Seattle Times* critic to compare him with Josef Albers, finding Kenney "more occult, more subtle, and highly poetic."[1] Alan Watts bought a painting from that exhibit, and another Kenney painting, reproduced in *Art in America,*[2] was chosen to illustrate an essay by Joseph Campbell. In Seattle, Kenney was a star. Art critic and novelist Tom Robbins hailed him as heir to Mark Tobey and Morris Graves[3] and wrote an enthusiastic essay for the retrospective catalog.

At the time of the SAM show, Kenney had already begun work on a new series of paintings, more spontaneous than anything he had done in years. He called them his "geometrics." For the previous decade, Kenney had been devising various conjugations of circles and squares, mostly in symmetrical arrangements. Now he unshackled his compositions and set them loose in dancing skeins of triangles, trapezoids, hexagons, and parallelograms, over washes of increasingly daring color.

Then, in 1977, he assembled a show for Foster/White Gallery. People loved it. Richard Campbell, writing for the *Seattle Post-Intelligencer,* described Kenney as "a colorist of the first order,"[4] and *Seattle Weekly* called Kenney's abstractions "astonishing."[5] At the time, Kenney was in his early fifties and at the height of his abilities. No one could have guessed that the following show, in 1979, would be his last gallery exhibit.

Inception of Magic

As a child, Kenney was enthralled with the rituals of the Catholic Church, the way the candlelight flickered through incense smoke in the dark interior of the cathedral. For him, a church interior was an oasis of calm and mystery in a difficult childhood. He soon found a similar escape in art.

Born in Spokane in 1925, Kenney moved to Seattle at the age of six with his parents, Raymond and Doris Kenney, and older brother, Jack. It was the depression, and times were hard. The family moved around, from an apartment on Summit Avenue, to a house near Green Lake, to one on Meridian, then to another at 4117 Wallingford. With Kenney's father in poor health, they moved, finally, to an apartment at Olive and Summit.

Kenney took his first art class at Alexander Junior High, where his teacher brought small oriental figurines to class for her students to draw. When Leo went on to Lincoln High School, his teacher was less sophisticated. "Art classes in those days mostly meant soap-carving," he recalls, ". . . little pigs and chickens."[6] Kenney made the best of it. He soon discovered that the school had a beautiful art library, full of old books with exquisite tinted reproductions. He spent his lunch hours there, fascinated by the botanical illustrations and the Delacroix paintings.

Kenney was seventeen when his father died. His brother Jack was away, serving in the National Guard, and Leo had transferred to Broadway High, where he had a real art teacher, Jule Kullberg. With her instruction, "everything opened up," Kenney says. "We were all drawing from models; I learned about oil paint, and my teacher had all these art magazines. That's what I discovered there—all the living art."

It was during that art class, shortly after the bombing of Pearl Harbor, that military police interrupted school and pulled all the Japanese students, close friends of Kenney's, out of class. Nobody knew what was happening. Their teacher was too upset to go on and dismissed her students for the day.

As a boy, Kenney had helped out with family finances by delivering papers and theater bills, but in high school, he began working nights as a busboy at his uncle's restaurant in Pioneer Square. He remembers putting in overtime, saving his pennies, so that he could buy *The Secret Life of Salvador Dali.* Smitten with the extraordinary things he was seeing in art magazines, Kenney pestered Kullberg for more information. Abstract art intrigued him, and he kept asking her about it until she told him, "Leo, I can't answer these questions. You should go to the art museum and see the work of Mark Tobey and Morris Graves." Kenney went, and it changed his life: "I was never so knocked out as when I first saw Graves's *Morning Star* and *In the Night.* . . . It was an epiphany to come upon his work—the originality of it."

On his eighteenth birthday, Kenney quit high school, determined to be an artist. Just a year later, at the precocious age of nineteen, he had his first exhibit at the Little Gallery at Frederick & Nelson. It was a two-man show with another artist who went on to a distinguished career—James Washington Jr. In those days, when Seattle had no independent galleries and few places to exhibit art, the Little Gallery was a respected institution. Artists went there to see the latest, and Kenney began meeting some of the most exciting Northwest painters of the day—Tobey, Graves, Leona Wood, Guy Anderson, Clifford Wright—who became his friends and associates. No reviews exist of that first exhibit, but we can assume response was good. The following year, Dr. Richard Fuller, founder and director of the Seattle Art Museum, purchased for the museum its first Kenney painting, *Inception of Magic* (pl. 1).

We know that Tobey and Graves were aware of Kenney's work. The two older artists, strolling through the museum stacks one afternoon, were overheard handing down their royal verdicts as they stood in front of *Inception of Magic.* Kenney's friend Clifford Wright, who eavesdropped on the conversation, eagerly reported their remarks back to him. Tobey,

he said, had declared that Kenney should take all that technique and go back to painting still lifes—implying that the young painter had skipped too blithely into abstraction and should first thoroughly learn the basics. Graves, on the other hand, found the work well executed but without "soul."

Thrilled that such luminaries had noticed his work at all, Kenney took the comments to heart. He began a series of paintings that would establish his ability to paint figures, eschew color for moody tonal modulations, work with multiple perspectives, and still dredge his unconscious for symbolic content, looking for that elusive thing that Graves called soul.

1945–62: Psychology Was Everything

The country was at war. Classified 4F for military service—he had failed his induction physical—Kenney devoted himself to absorbing everything he could about painting. He hung out at bookstores, spending his paychecks from the Hardeman Hat Company, where he'd gotten a job in the packing room, to buy the latest art books. Surrealism was still thriving, and Kenney had been reading about it for years. Through his subscription to *View* magazine, an avant-garde publication out of New York, and any exhibition catalogs he could get his hands on, Kenney gorged himself on the imagery of Dali, Matta, Max Ernst, and particularly Giorgio de Chirico, whose influence on Kenney was profound.

In those early days of his painting, Kenney was preoccupied with sorting out the effects of his Catholic upbringing, dealing with the absence of a caring but difficult father, and coming to terms with his own sexuality. Basically, what he was looking for were clues to himself. "Psychology was everything," he recalls. "The surrealists were all about that. Freud was just in the air when I was in my twenties." What Freud gave artists was the notion of the unconscious, the secret habitat of the muse—the place, literally, where dreams were born. The trouble was, you couldn't just go knock on the door with your eyes wide open and hope to get in. So poet André Breton devised the notion of "psychic automatism," defined in his *Manifesto of Surrealism* as "dictation of thought, in the absence of any control exercised by reason, exempt from any aesthetic or moral concern."[7]

Kenney has an amazing visual memory—whatever his eye takes in, his mind retains. Over the years, he had amassed a vast horde of imagery just waiting to be tapped. He thought the surrealist technique was a great idea—"like James Joyce's stream of consciousness"—and so he began painting automatically, with no planning, no editing. Old notions about reproducing reality—Kenney had passed his high school botany class by painting meticulously detailed plant studies—got pitched out under the sway of Breton's precept that "the marvelous is always beautiful, anything marvelous is beautiful, in fact only the marvelous is beautiful."[8]

Although Kenney would later become known for his exquisite technique with gouache, an opaque watercolor, in his early years he worked in oil and tried out various water-based pigments. When he painted *Inception of Magic* (pl. 1) in 1945, he was experimenting with egg tempera, a translucent medium that Kenney admired for its versatility. "I saw works

FIGURE 1
Electric Night, 1944
Artist: Mark Tobey
Tempera on board
Seattle Art Museum,
Eugene Fuller Memorial
Collection

FIGURE 2
Owl, 1943
Artist: Morris Graves
Gouache on paper
Seattle Art Museum,
Eugene Fuller Memorial
Collection

that Margaret Tomkins and James Fitzgerald did with it, and Leona Wood, so I just tried it out," Kenney says. "It can be used so many different ways—sometimes you can't tell it from oil. Of course that was during rationing [for the war], and eggs were hard to get."

The focal point of *Inception of Magic* is a circle, ensconced like a great pearl in the body of an oyster. The entire painted surface of the rippling, sea-soaked abstraction undulates with cosmic activity, an illusion of vast space: little planets arc through their orbits; sperm wriggle; cells divide in watery microcosms; tiny stars, a crescent moon, triangles, glowing jewels, chalices, all shiver and squirm in a primal broth. The central form—easily associated with an abstracted human torso—wavers in a placental wrapping like a sea anemone or the nebulous sprawl of the Milky Way; it could be a womb or the universe.

The source of all this imagery flowing through the young artist's egg tempera–soaked brush—so new and revealing to him—was, certainly, the sea of his unconscious. But the form it took owed a good deal to the work being done around him at the time. Besides the obvious kinship with Tomkins's writhing biomorphic forms of that period, similar to work being done by Kenneth Callahan, Kenney's *Inception of Magic* relates formally to Tobey's *Electric Night* of 1944 (fig. 1). But Kenney has always been particularly influenced by the imagery of Morris Graves. The enveloped form of Graves's 1943 painting *Owl* (fig. 2)— radiating an aura, or sheltered in a perennial womb—is a motif that Kenney, like Graves, would continue to explore throughout his career.

In his early paintings, Kenney also paid homage to the work of de Chirico, whose odd juxtapositions and eerie perspectives put him in league with the surrealists. Two Kenney paintings from 1948—*Northern Image: Muse III* (pl. 8) and *Third Offering* (pl. 10)—reflect Kenney's attraction to de Chirico's work. The elongated, robe-draped figures in both paintings resemble those in de Chirico's early drawings, and Kenney's composition in *Third Offering* echoes compositional elements of de Chirico's *Conversation among the Ruins* (fig. 3), with its figure gazing through an open portal toward the vanishing point.

This phase of Kenney's work drove his friend and fellow painter Richard Gilkey a bit crazy. Kenney would start a painting like *Northern Image* with just a head, perhaps the head of a muse, plunked down on the canvas, and no idea what else was going to happen. Gilkey would stop by the studio and be aghast that Kenney had no idea about the composition, or even what he was going to paint next. "Gilkey would have to leave," Kenney laughs. "He couldn't stand it. 'What are you going to do with that?' he'd say. And I said: What I'm going to do is invent a world to go around her, for her to inhabit. I'm pulling her out into it like an obstetrician."

Kenney's mother remarried and moved with her new husband to Long Beach, California, where they bought a small apartment building. For several years, Kenney moved back and forth, up and down the coast between Seattle and Long Beach, where he rented an apartment from his mother. Finally, in 1952, he settled in San Francisco, where he took a job in the display department at Gump's. "That was a learning period about oriental art," Kenney says, "and Gump's was *the* place to learn it. . . . Now it's more a mail-order house,

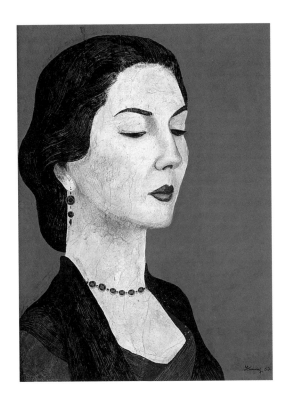

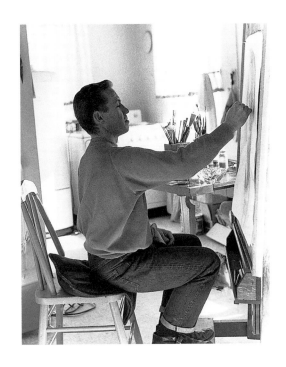

FIGURE 4
*Study for a Portrait of
Leona Wood,* 1952
Gouache on Chinese paper
Collection of the artist

FIGURE 5
Leo Kenney, Bodega Bay,
California, 1961

but then it was a place where museums bought things. Richard Fuller was a good friend of Solomon Gump. That's where Dr. Fuller bought the camels and the tomb warriors [for the Seattle Art Museum] in 1933."

Asian art and religion influenced Kenney's aesthetics, but he maintains that the symbolic content of his paintings owes much more to his Catholic upbringing than it does to Zen. He relates the chiaroscuro of his early work to his love of attending evening mass at Saint Benedict in Seattle, seeing the shadowy church awash in candlelight and incense. The incessant gray moodiness of 1940s Northwest painting, often attributed to the weather, undoubtedly rubbed off on the young painter as well. After moving to San Francisco, he began to broaden his palette and his imagery. Recurrent Piscean motifs of the sea and swimming figures appear in stylized, symbolic compositions such as *Voyage on an Inner Sea III* (pl. 17) and the *Night Swimmer* series, to take their place alongside Kenney's chalices and sacramental offerings.

From time to time, Kenney also made portraits of his friends, including Jan Thompson, Betty Bowen, Zoe Norwood, and Richard Gilkey. The portraits, a little-known aspect of Kenney's oeuvre, have something of the tone of religious icons. Icons of beauty, at any rate, because all Kenney's subjects are exceptionally good-looking. Meticulously detailed, usually in three-quarter profile, the faces are stylized and exotic. The stunning magenta ground of his 1952 gouache study of artist Leona Wood (fig. 4) signals the opulent colorism that would characterize his later work.

By the late 1950s, Kenney began to systematically pare down his imagery, removing the obsessive detail, as he moved back again toward abstraction. You can see the relationship

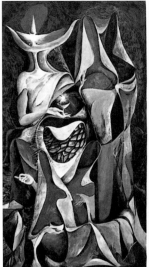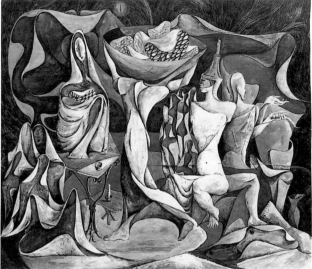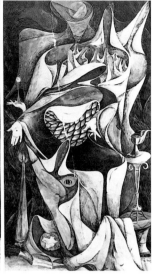

FIGURE 6
The End of the Golden Weather,
1945–46
Triptych; gouache on paper
Location unknown

of the womblike form of *Inception of Magic* (pl. 1) to the hollow "envelope people" in the 1945–46 gouache triptych *The End of the Golden Weather* (fig. 6; now lost). The figures, partly inspired by Henry Moore's sculptural forms, developed in *Final Movement* (pl. 2) and then transformed into the encasement of the *Night Swimmer* series of the 1950s, which Kenney continued to refine until 1962.

That same year, Kenney painted *Episode* (pl. 26), an image of toppling vessel forms that evokes the motion of Marcel Duchamp's *Nude Descending a Staircase.* The silent fall of Kenney's image is stylistically removed from the threshing commotion of Duchamp's, but the comparison is striking. Both artists can be seen hovering at the point of abstraction: Duchamp by dissolving the figure into the refracted planes of cubism; Kenney by systematically removing any characterizing detail. During this period, Kenney also painted *Relic of the Sun* (pl. 18), a classical Greek torso, a sculptural remnant, with the sun's red disk hovering over it in place of the head. At this point, he had reduced the figure to its bare essentials, had purged his unconscious of latent symbolism, and was about to begin a new quest.

1962–73: The Seeker

According to Kenney, the images he saw during a single experience on mescaline in 1962 pushed him over the threshold of abstraction in his painting. "That was the trigger," he said. The drug may have provided the impetus, but if you look at the work leading up to that point, you'll see that the step was inevitable—it's where the paintings were headed. Another factor that entered into Kenney's stylistic shift was a change in materials. Some friends traveling in Asia bought him a large roll of Chinese paper. He had been working alternately in oil, for paintings such as *Relic of the Sun,* and gouache, for the *Night Swimmer* series and *Episode.* The new paper was big and challenging—the surface took paint differently—and Kenney found it exhilarating. "This paper was a revelation—really exciting," he said. "I'd never done great big washes. I had to find a new technique." He began

to set technical tasks for himself, and to visualize his compositions in advance. He used the most basic forms—primarily circles and squares—in conjunction with intricate, pointillist detail.

This is what Tom Robbins, writing in 1973, called Kenney's "Jungian" period, and the name has validity. Kenney, like everybody else, read Jung during the 1960s and was tuned in to the significance of the mandala and its place in Tibetan Buddhist art, to Egyptian religious symbolism, and to the ancient Chinese philosophy expressed in the *I Ching*. Now, with the perspective of a quarter century, it's more relevant to call the paintings "conscious" in opposition to the earlier, automatically executed "unconscious" images. They are a departure from the highly subjective, explicitly psychological work in favor of a more objective, spiritual exploration. Kenney's figurative work reflects the influences of surrealism seen through the darkened lens of Northwest regionalism, but it is primarily an act of introspection, an expression of self-discovery and emotional longing. After 1962, Kenney's work turns toward a metaphysical exploration that made him seem the logical heir to the crown of Northwest mysticism.

As a young artist, Kenney had unconsciously absorbed and mimicked imagery by Tobey; now, as a mature painter, he understood it. Kenney admits that during this period, he began to appreciate Tobey more and more. But from the beginning, Kenney had resonated more closely with Graves's images of light and transformation and had assimilated the Gravesian aura, the transparent encasement that seems at times to trap his figures like a gauzy net; at other times, to emanate from them like energy. Now, moving from figuration to abstraction, Kenney once more found himself gravitating to the forms he had seen in Graves's paintings of the 1940s, such as the *Rising Moon* series, *Black Buddha Mandala,* and the vertical ascension of *Kundalini* (1953). At this juncture, Kenney was ready to take those shapes and that sense of motion, drench them in prisms of color, and make them his own.

While maintaining close ties with his artist friends in Seattle, Kenney had been based in California for more than a decade. In 1963, he sent some of his recent abstract paintings to Dr. Fuller at the Seattle Art Museum, to acquaint him with the new direction of his work. Fuller's response was polite, but Don Scott, then working as a technician at the museum, had unpacked the paintings for Fuller and admired them. He wrote to Kenney, offering him a show at his new gallery. Kenney accepted the offer and, ready for a change, moved back to Seattle. The show opened at the Scott Galleries in September 1964. Tom Robbins, enthusing about the new paintings in a review for the *Seattle Times,* said that Kenney, in returning from California, "securely regains a lofty position in the ranks of Northwest artists."9

Despite Kenney's roots in the Northwest regionalism of the 1940s, his work of the 1960s and 1970s requires a larger context. For one thing, the core of the Northwest School had dispersed. Graves and Tobey had moved away. Callahan, still a spokesperson for regional artists, had not evolved significantly. The mantle of the Northwest School had fallen to Guy Anderson, living in relative isolation in La Conner, where he developed a link between Northwest Indian imagery and the tales of Greco-Roman mythology. Anderson's

FIGURE 7
Leo Kenney, Seattle, 1968

style, by the 1960s, was distinct from other painters of the region.

The abstract work that Kenney began in California and continued after his return to Seattle in 1964 relates easily to what was happening on the national scene. Principles of color-field painting, op art, and even pop art sidled into Kenney's conscious abstractions. Each painting grew from a carefully controlled color wash that, when dry, became the night sky to Kenney's formal fireworks. His compositions and primary forms were simple, but haloed with explosions of color and pointillist detail. He could create illusions of enormity, or zero in on the minutiae of cellular division.

Seed and Beyond II (pl. 33), for example, is a stratified oval adrift in the picture plane like a star system nosing through deep space. Symbolically, the image represents a seed pulsing energy from the potential flower at its core, but the suggestions that emanate from it are endless. It could be an embryo swaddled in a fabric of effervescent light, the vast reaches of the solar system, or the intimate comfort of a mother's breast. It could be a cross section of the tree of life, the navel of the universe, the thumbprint of God.

Though Kenney's imagery can revel in impeccable technicality, it never abandons metaphor. When the work falls short, it may appear static or a little too sweet, but never meaningless. Kenney has said that he could never be a Rothkoesque painter of the void: he wants content in his work. The abstract paintings, far from being formal exercises, are emotive, strongly suggestive arrangements of archetypal forms.

Kenney worked consciously with circles, ovals, and squares, in mostly symmetrical arrangements. The concept of the mandala, a potent religious symbol of the self and the universe—a tool for meditation—motivated his compositions. The gouache paintings, the majority of Kenney's output, are luminous and intricately simple: stark compositions with amazing delicacy of detail. They range from simple tondos, like the subtle color gradations of circles within circles in *Rapport III* (pl. 37) and *Soft Red* (pl. 44) or the filmy explosion of light in *Golden Seed* (pl. 47) to the diverse arrangements of *Vertical Transformation* (pl. 41) and *Seeker: To David Stackton* (pl. 42).

The ascending forms of these and other Kenney paintings of the period suggest the stacked figures of totem poles and the upward surge of the yogic chakras (depicted by Graves in *Kundalini*), and can relate to the human torso—the form implied in *Inception of Magic* (pl. 1) and depicted in *Relic of the Sun* (pl. 18). But *Seeker: To David Stackton* also

FIGURE 8
Leo Kenney, Seattle, 1992

compares well with the abstracted sexuality of *Dualogue* (pl. 27). In *Dualogue,* a radiant, lunar orb hovers above a shadowy pelvic form, yin and yang. With a sword blade aligned precisely toward the center of the circle, the image is all phallic tension, eternally poised at the moment before penetration. In *Seeker,* the dark and light forms have coupled, like pieces of a puzzle, and the metaphorical tension of the image is resolved. The motion in the piece is purely retinal, as negative and positive space interact, colors advance and recede, light plays against the void.

Some oils Kenney did during this period abandon the lyricism of the gouache paintings for a concise rendering that relates to the hard-edge abstractions of Albers while toying with the pop palette and sensibility of Roy Lichtenstein and Andy Warhol. Although Kenney denies any interest in pop art, his *Communicator* (pl. 35), another mandala-like arrangement, is painted with an ironic twist. He places the form atop a pedestal that resembles a human neck and shoulders, so the image jolts out of abstraction and comes to life. Kenney says he had a radio in mind, but the image also suggests a space-helmeted astronaut about to lumber out onto the moon or a robot broadcasting electronic messages through space in search of intelligent life. Whether or not it was intentional, *Communicator* evokes popular culture imagery from comic books, science fiction, and television shows.

These conscious abstractions of Kenney's resonated so perfectly with the tenor of the times—the space program, the fascination with Jungian archetypes and Eastern philosophy, the advent of light shows and psychedelic imagery, the convergence of pop and Minimalism with geometric abstraction—that Seattle-area artists, critics, and patrons alike were wowed by what they saw. Robbins, writing for *Seattle Magazine,* proclaimed: "Kenney has recouched the spiritually penetrating statements of Morris Graves in the popsicle-flavored hedonistic, General-Dynamics-Surrealist jive of Billy Al Bengston. Without resorting to the illustration or gimmickery of Pop art, he has made the Haida totem-pole fall into place alongside the Texaco gas pump."[10]

Outside curators and dealers began to take note. In 1967, the National Institute of Arts and Letters presented Kenney with a $2,500 award and displayed nine of his paintings at the American Academy in New York. The following year, his work was featured in the traveling exhibit *West Coast Now,* which showed in Los Angeles, San Francisco, Portland, and Seattle. Marion Willard gave him a show at her New York gallery in 1968. It was then that Alan Watts bought a painting and that another Kenney image was selected for the cover of *ARC Directions,* the journal of the Society for the Arts, Religion, and Contemporary Culture, to illustrate an essay by Joseph Campbell. By the early 1970s, the Seattle Art Museum began assembling its retrospective.

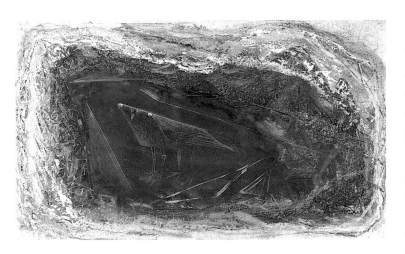

FIGURE 9
*Little-Known Bird of the
Inner Eye*, 1941
Artist: Morris Graves
Tempera on tracing paper
The Museum of Modern Art,
New York. Purchase.

A New Cosmology

When that show opened in 1973, Kenney was forty-eight years old and well on his way to national success. Marion Willard was eager to install another show at her New York gallery. Kenney's Seattle dealer, Don Foster, was selling everything Kenney gave him. But, like the turning of events described in the *I Ching* and illustrated in the transformations of Kenney's imagery, the seeds of change had already germinated. Years of hard drinking and smoking were taking a toll on Kenney's health. His painting technique required him to spend long hours on his feet, hunched over a table where his paper lay flat. It was intense work. The infinitesimal detail called for sharp vision, a steady hand, and relentless concentration; a careless moment would destroy the painting. Just applying the initial color wash could be nerve-racking, with colors shifting and running until the paper dried. Kenney has likened it to baking a soufflé: "You have to watch it every minute."

The work was arduous, and Kenney's output had always been small and erratic. He felt under pressure, and turned down a second show at the Willard Gallery. He couldn't produce enough work to supply two dealers. Besides, such a demand for work can be inhibiting, and Kenney was beginning to feel that he had exhausted the possibilities of the circle paintings.

At his retrospective, Kenney showed one painting that marked a change in the direction of his work. A large rectangular expanse that laps out to the edges of the paper in waves of modulated color, *A New Lake* (1972), was first in a series that Kenney would call *Geometrics.* As close to pure color-field painting as Kenney ever came, *A New Lake* is the simplest, and least dimensional, composition of the series that grew out of it. Kenney quickly moved on to *Lake Gemma* (pl. 52), a blue crystal encased in strata of glowing neon. Like a shimmering prism or a cross section of a star, *Lake Gemma* draws the eye toward its core, a vanishing point in infinite space. With those two paintings, Kenney once more expanded his vision, which began with an inward gaze at his own psyche and then turned to encompass the human spiritual potential. Now, in his final series of work, Kenney looks to the cosmos, to the birth of galaxies and the dissolution of stars. What he finds, in their vastness, is the microcosm of life on earth: molecular strands, the division of cells, the dualities of human nature, and a spectrum of color as dazzling as any jewel.

Once again, the directional shift in Kenney's work when he painted *A New Lake* was in part precipitated by a new material. He was running out of Chinese paper and began to try out different surfaces. "I was tired of working on circles. I knew it would get to be formulaic

if I didn't watch it," Kenney said. "So I was not only experimenting with this new paper—which I never used again, by the way—but was kind of washing the slate clean. I was having fun. Then I went on to *Lake Gemma* and into using those little geometric shapes: hexagons, parallelograms, squares. . . . I thought of those little forms as an alphabet and with them I would write these new paintings."

Fresh as the images were for Kenney, their evolution traces back through all the phases of his work. Look at *Reclining Dreamer* (pl. 3) and *Blue Swimmer* (pl. 21)—and then see their reflections in *Lake Gemma* (pl. 52), *Diamond Lens* (pl. 54), and *Crystal Ship II* (pl. 55). That womb-encased horizontal form also bears a striking similarity to Graves's 1941 painting *Little-Known Bird of the Inner Eye* (fig. 9), a cubistic abstraction of a bird form, calcified like a fossil at the heart of a stone, in strata of transparent red. This progression of imagery doesn't diminish the significance of Kenney's late paintings—it makes them more deeply satisfying. They have the logic of a lifetime of development, a natural progression from seed to flower, that marks art of the highest order.

At this point, Kenney learned to break free of the symmetry that made his work harmonious but could at times suck the life out of his compositions, leaving them flat and motionless. He grew daring and playful in works like *Floating Forms* (pl. 57), two radiant spires, gyrating in space like strands of DNA, or the gorgeous *Flight over Red Cloud* (pl. 56), an aggregate of geometric forms hovering, like the intellect, over a searing red vapor of instinct and emotion that can't be contained in the bounds of the picture space.

Another particularly daring composition, *Preceding Spring II* (pl. 63), is a group of pulsating triangles, squares, and diamonds that tips to the lower left corner while luring the eye back to the upper right with a free-floating shadow. The forms maintain their acrobatic balance amid a simmer of vaporous colors: eye-shocking citrus and raspberry almost ignite against icy cornflower, turquoise, and sapphire, adrift in a slurry of seaweed green.

It took Kenney four years to get together a dozen paintings for a show at Foster/White Gallery in 1977. Several pieces—sold at the time they were painted so that Kenney would have money to live on—had to be borrowed back from collectors. Richard Campbell, reviewing the exhibition for the *Seattle P-I* under the headline "A Rare Show for Leo Kenney," found the paintings exceptional and used paradox to describe their impact: "They define the undefinable, create mystery about the obvious."[11]

Kenney, continuing to work sporadically, fell and broke his hip in 1982. His health deteriorated. Painful surgeries to repair the hip weakened him, leaving him unable to stand for the long hours his paintings required. What he painted, he sold immediately, to help cover expenses. But with no exhibits of new work year after year, curators forgot about him. Critics had nothing to write about. By the 1990s, Kenney's career, after its meteoric rise, was nearly forgotten.

Kenney might have faded into history if not for the dedication of Seattle attorney Merch Pease, who has spent countless hours researching and cataloging Kenney's work. Barbara Straker James, curator for the Museum of Northwest Art, and Jake Seniuk,

director of the Port Angeles Fine Arts Center, deserve credit for bringing Kenney's work back into the public eye. In 1996, Seniuk, relying on Pease's archive, was able to assemble *Leo Kenney: Geometrics,* an exhibit of Kenney's post-retrospective paintings. The show included images from the last Foster/White Gallery exhibit, almost two decades earlier, and also brought together for the first time the paintings done since then, which had been so quickly dispersed. It was stunning, a revelation of Kenney's finest work.

The show also confirmed the importance of this retrospective by the Museum of Northwest Art, which has been on the museum's roster since the early 1990s. *Celebrating the Mysteries* was carefully curated by Barbara Straker James with insights from the artist. Kenney, in delicate health after cancer surgery, also graciously gave his time in interviews for this essay.

What we see in *Celebrating the Mysteries,* which spans nearly fifty years, is the systematic, disciplined progression of an artist whose work developed in synchronicity with the spirit of the times and, in the end, transcended it. There is a remarkable unity in Kenney's work, although his style changed dramatically from the dark, unconsciously executed figurative images to his shimmering geometrics. Formally, the paintings are variations on a theme.

Kenney has said he listened constantly to Bach as he worked on the geometrics, and the images he created hold the same delicate balance as the music. Bach is so immensely satisfying because the compositions blend precise and methodical structures with heights of soaring emotion. Kenney, at his best, does the same. He balances the dueling needs of the human psyche for order and ecstasy. He began by purging the symbolic content of his own unconscious and then made meaning from those forms—first in a personal context, and then in a spiritual one. Kenney's mature paintings are cosmic diagrams that take us to the inner and outer limits of the human imagination.

NOTES

1. Jean Batie, "Leo Kenney Has NYC Showing," *Seattle Times,* April 1968.

2. Peter Selz with Tom Robbins, "West Coast Report: The Pacific Northwest Today." *Art in America,* November 1968.

3. Tom Robbins, "Heir to Tobey and Graves," *Seattle Magazine,* March 1968, 11–12.

4. R. M. Campbell, "A Rare Showing of Leo Kenney," *Seattle Post-Intelligencer,* January 14, 1977.

5. *Seattle Weekly,* January 19–25, 1977.

6. All Kenney quotes are taken from conversations with the author.

7. Cited in Mark Polizzotti, *Revolution of the Mind: The Life of André Breton* (New York: Da Capo Press, 1997), 209.

8. Ibid., 208.

9. Tom Robbins, "The Visual Arts," *Seattle Times,* September 13, 1964.

10. Tom Robbins, "Local Painters Re-appraised," *Seattle Magazine,* November 1965.

11. R. M. Campbell, "A Rare Showing of Leo Kenney," *Seattle Post-Intelligencer,* January 14, 1977.

Leo Kenney, ca. 1946

1. *Inception of Magic*
1945, egg tempera on masonite panel, 35½ × 23⅝ in., Seattle Art Museum, Eugene Fuller Memorial Collection

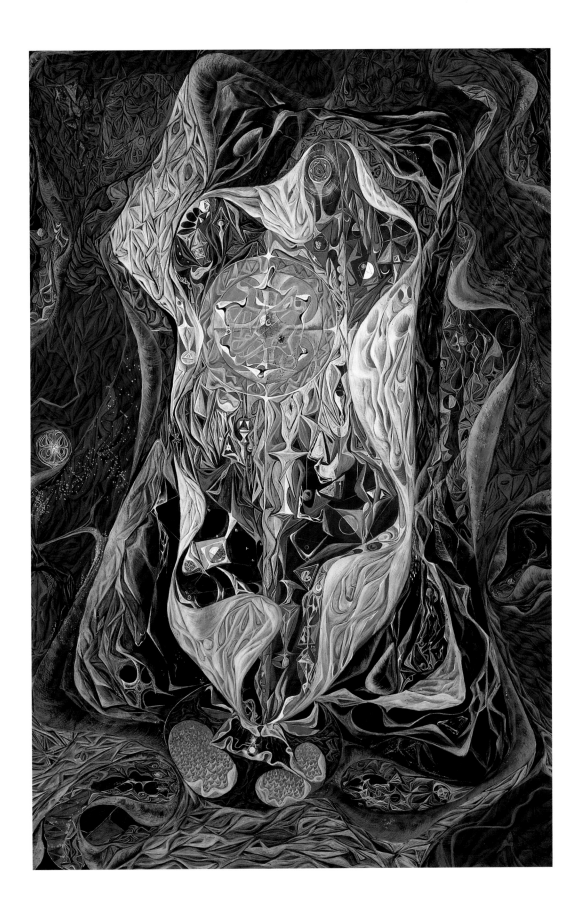

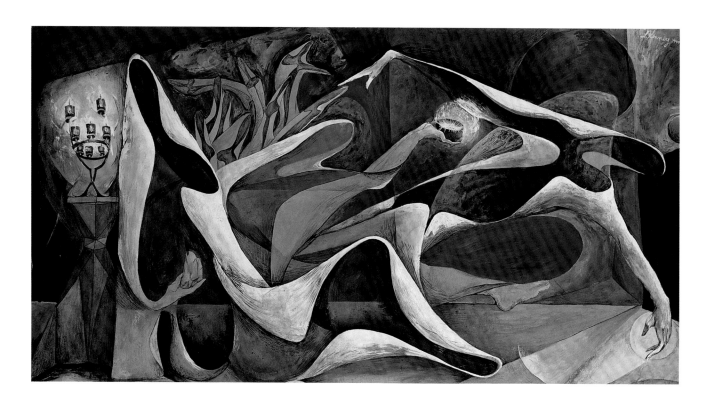

2. *Final Movement*
1946, gouache and ink on paper, 11½ × 21½ in., Janet Huston

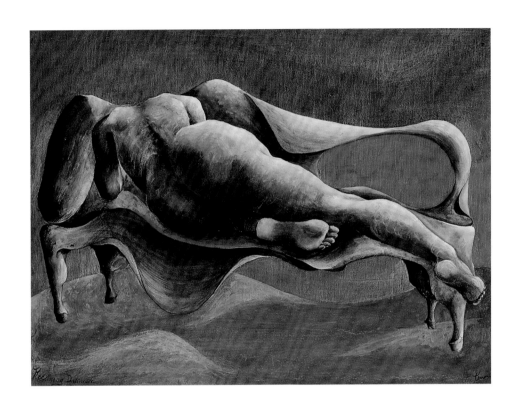

3. *Reclining Dreamer*
1946, gouache and pencil on paper, 11½ × 15⅝ in., John D. McLauchlan, courtesy of Martin-Zambito Fine Art

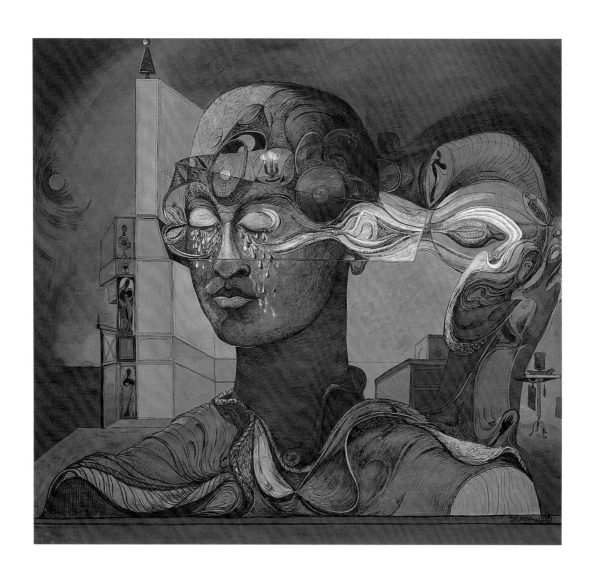

4. *The Crying Man*
1947, gouache on paper, 17¼ × 18¼ in., Museum of Northwest Art, promised gift of Marshall and Helen Hatch

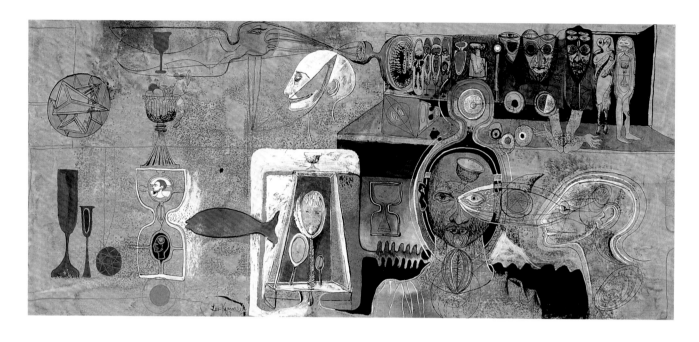

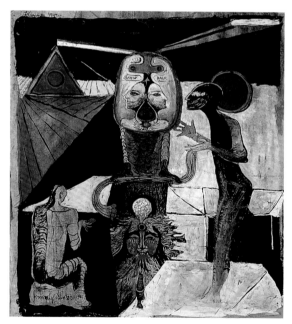

5. *Images*
1947, gouache and ink on Chinese paper, 10 × 21¾ in., Seattle Art Museum, gift of William D. Staadecker

6. *Journal of Winter*
1947, ink, watercolor, and gouache on paper, 10¾ × 9¾ in., Caryl Roman

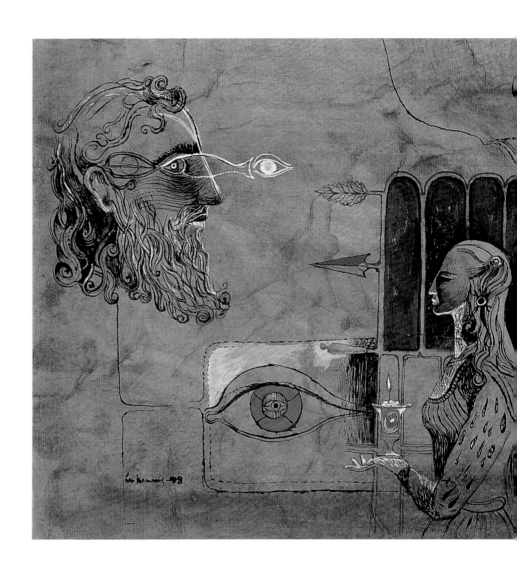

7. Metamorphosis
1948, gouache on Chinese paper, 9¾ × 23¼ in., Museum of Northwest Art, promised gift of Marshall and Helen Hatch

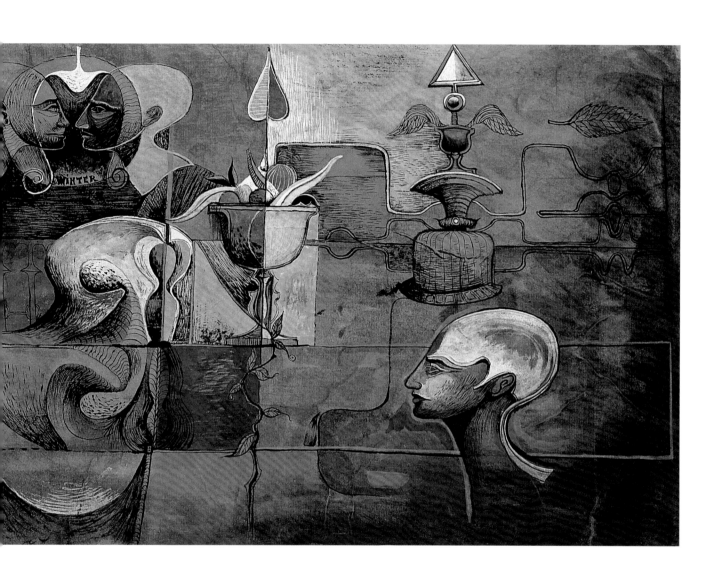

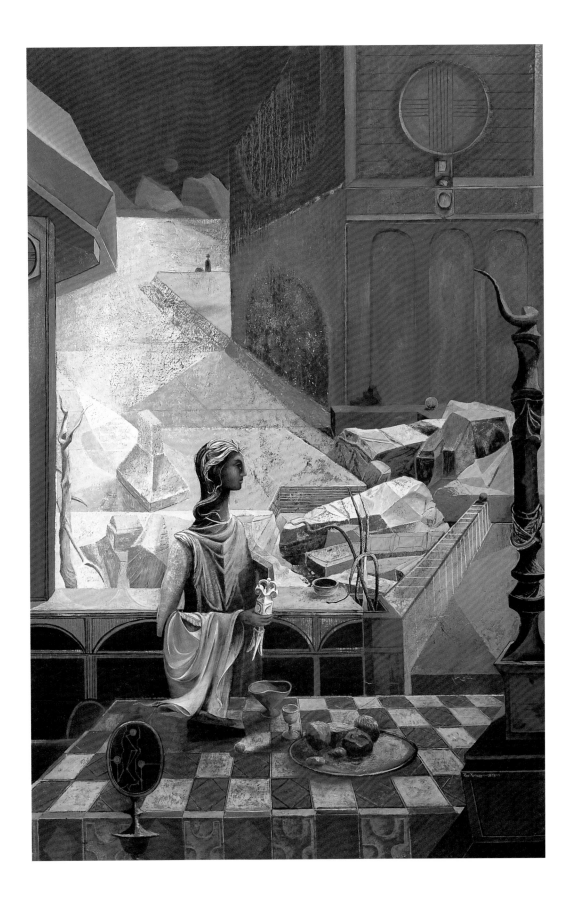

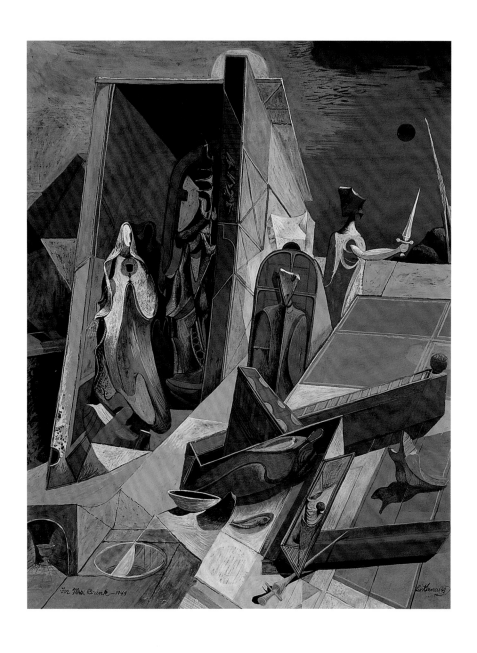

8. *Northern Image: Muse III* (opposite)
1948, oil on canvas, 29⅝ × 19½ in., Seattle Art Museum, Eugene Fuller Memorial Collection

9. *Protected Grail*
1948, gouache on paper, 15½ × 12 in., Merch and Alice Pease

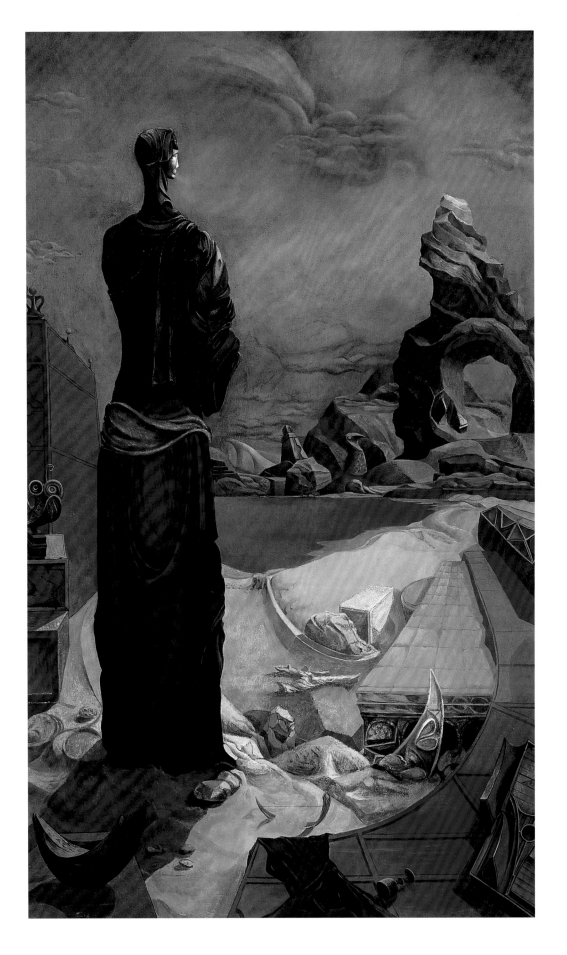

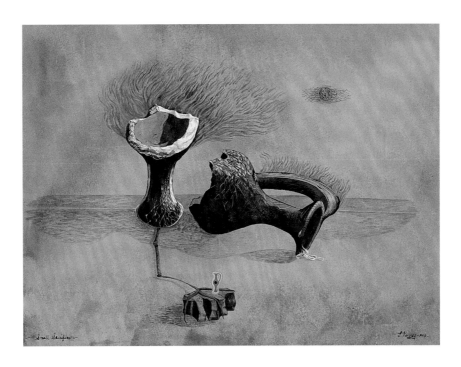

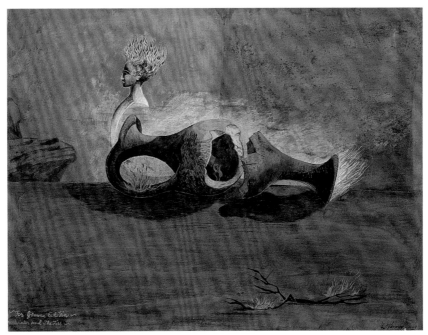

10. *Third Offering* (opposite)
1948, oil on canvas, 41¼ × 25⅜ in., Seattle Art Museum, Lowman and Hanford Purchase Prize

11. *Small Sacrifice*
1949, gouache and ink on paper, 10⅛ × 13⅝ in., Museum of Northwest Art, promised gift of Marshall and Helen Hatch

12. *Winter and the Fire*
1949, gouache on paper, 10⅛ × 13⅝ in., Museum of Northwest Art, promised gift of Marshall and Helen Hatch

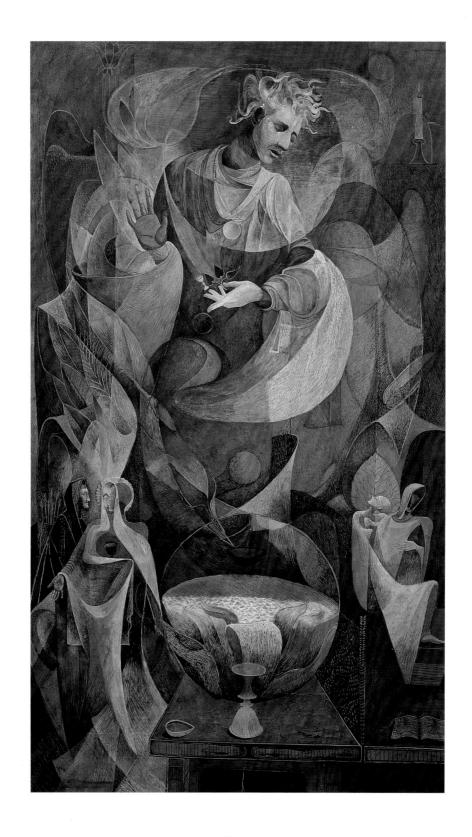

13. *Departure*
1950, gouache on paper mounted on board, 34½ × 23 in., Museum of Northwest Art, promised gift of Marshall and Helen Hatch

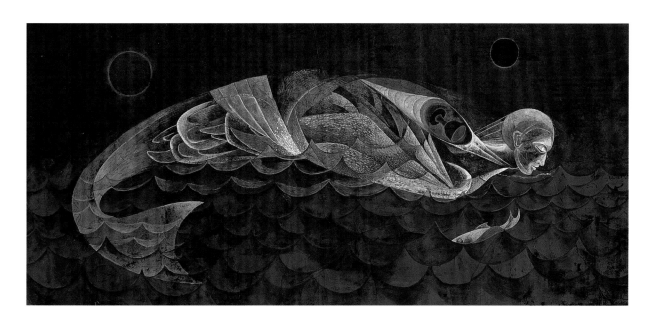

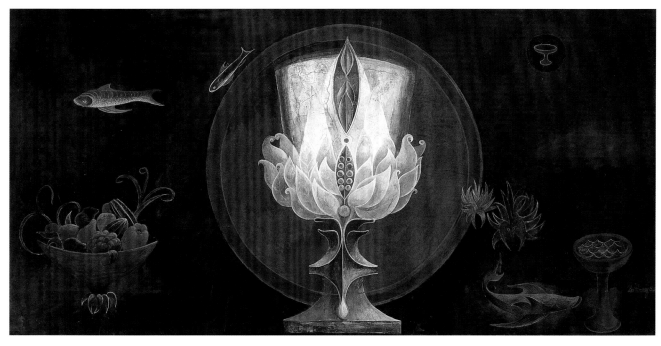

14. *Voyage on an Inner Sea II*
1952, gouache and gold leaf on paper, 9½ × 20 in., Jack Kennemur and Jack Strickland

15. *Offering of Seed II*
1953, gouache on Chinese paper, 18¾ × 39¼ in., Caryl Roman

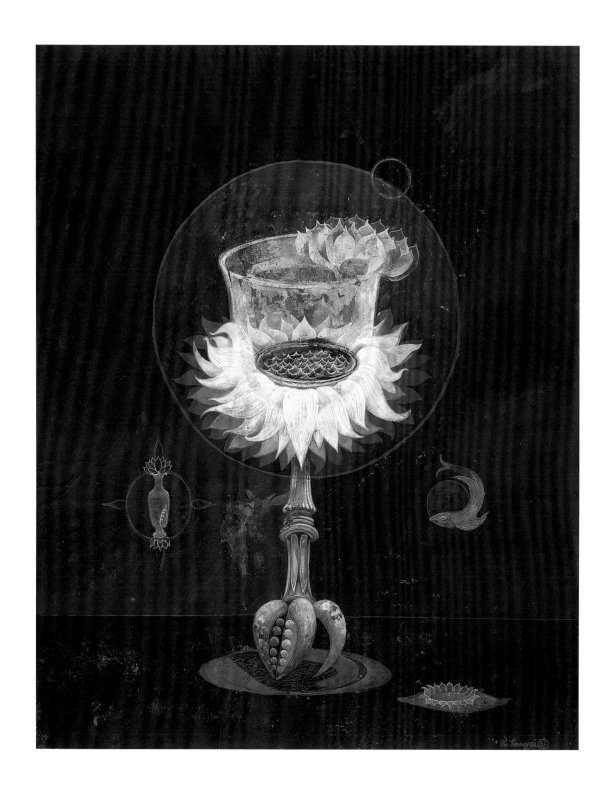

16. *Reliquary Flower*
1953, gouache and gold leaf on Chinese paper, 23 × 18½ in., Museum of Northwest Art, promised gift of Marshall and Helen Hatch

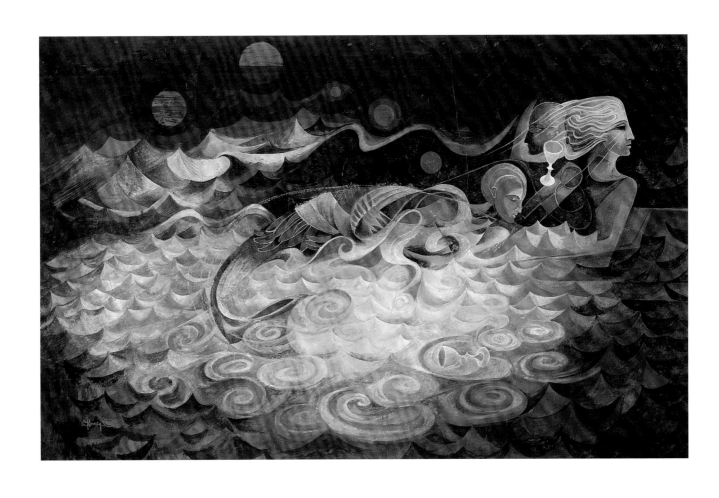

17. *Voyage on an Inner Sea III*
1953, gouache on Chinese paper, 19½ × 31¼ in., Museum of Northwest Art, promised gift of Marshall and Helen Hatch

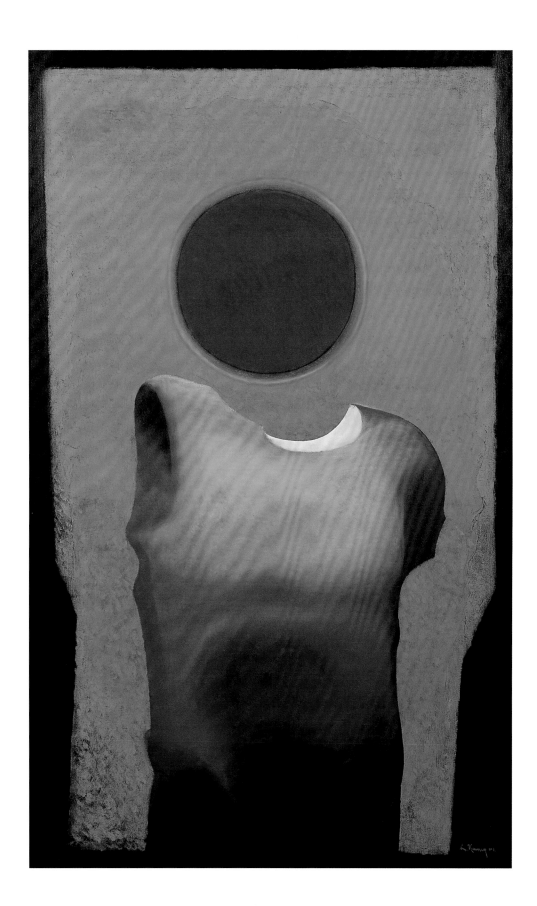

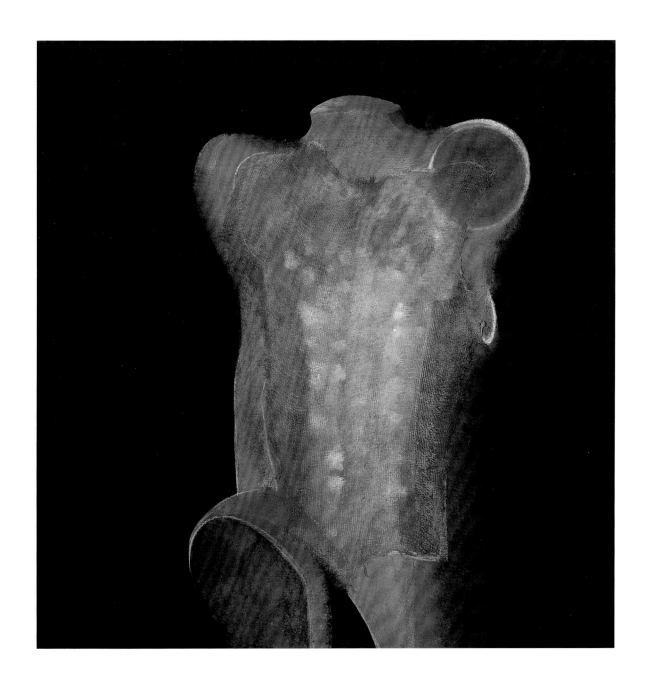

18. *Relic of the Sun* (opposite)
1961, oil on linen, 52 × 32 in., Merch and Alice Pease

19. *Relic*
1963, gouache and gauze collage on Chinese paper, 27½ × 27 in., Mary Randlett

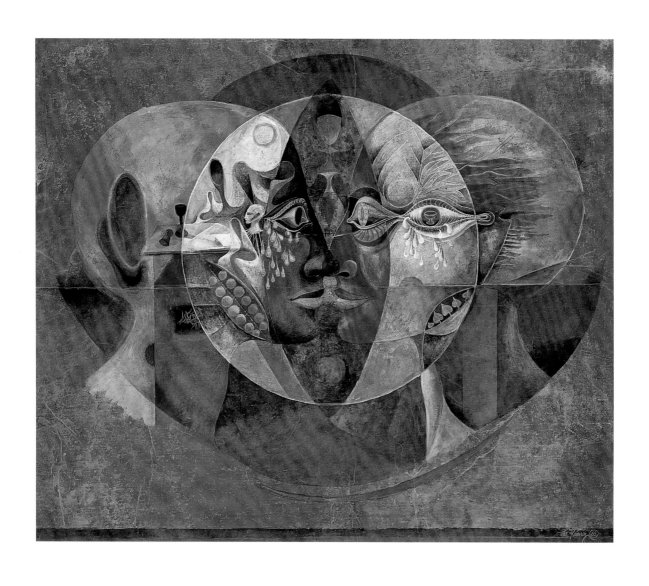

20. *Voyage for Two*
1953, gouache on Chinese paper, 19¼ × 23 in., Seattle Art Museum, gift of the artist

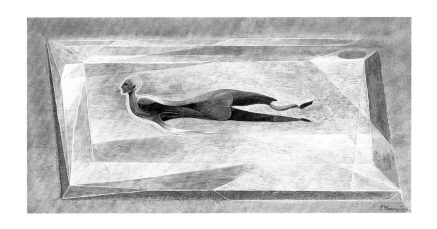

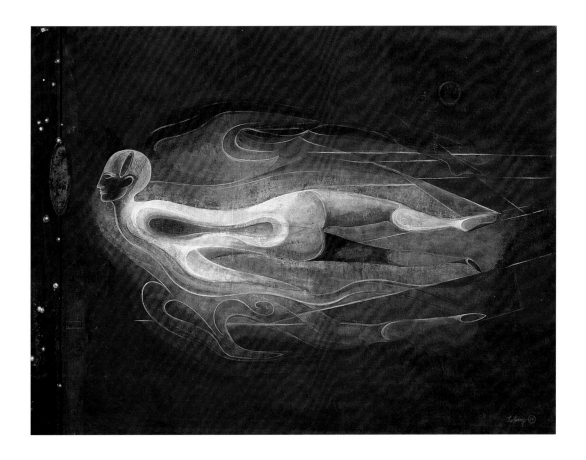

21. *Blue Swimmer*
1962, gouache on Chinese paper, 9⅛ × 18⅜ in., Jack Kennemur and Jack Strickland

22. *Night Swimmer II*
1954, gouache on paper, 18¾ × 24¾ in., Museum of Northwest Art, promised gift of Marshall and Helen Hatch

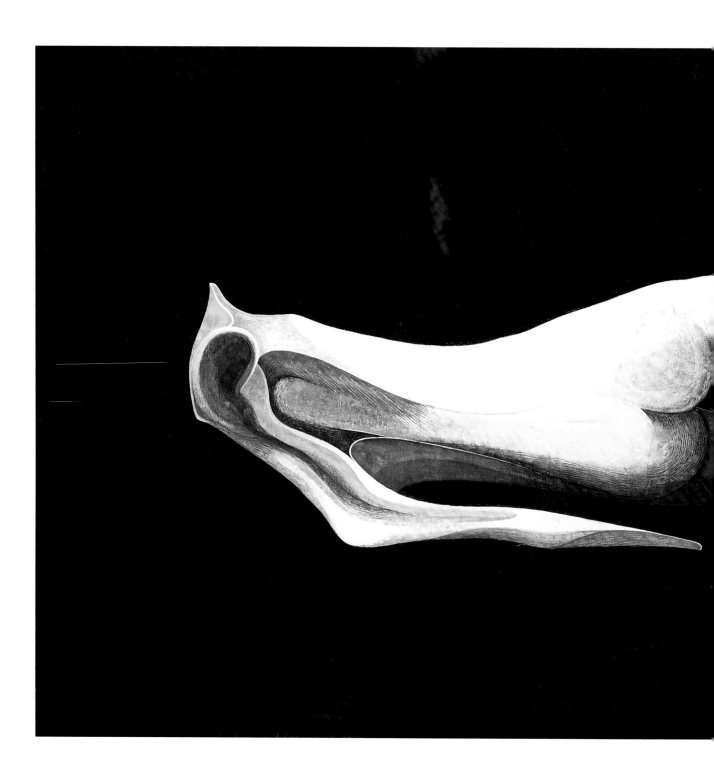

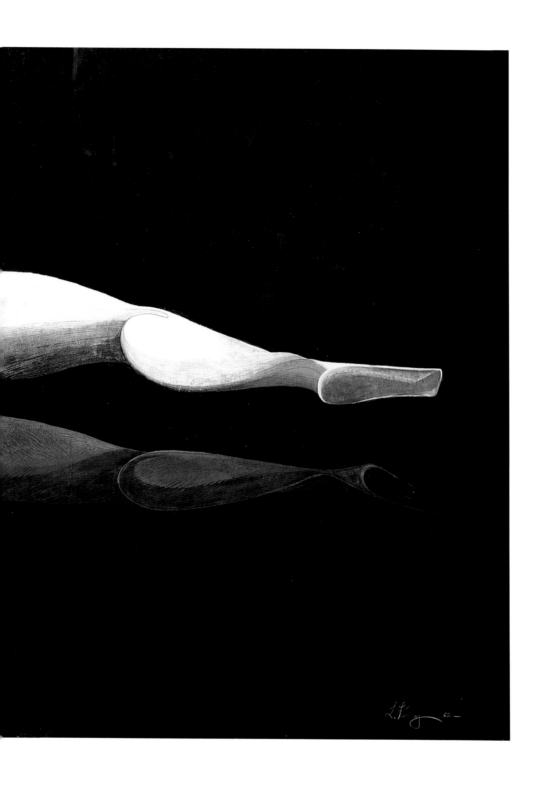

23. *Night Swimmer III*
1962, gouache and black ink on Chinese paper, 27 × 50 in., Jack Kennemur and Jack Strickland

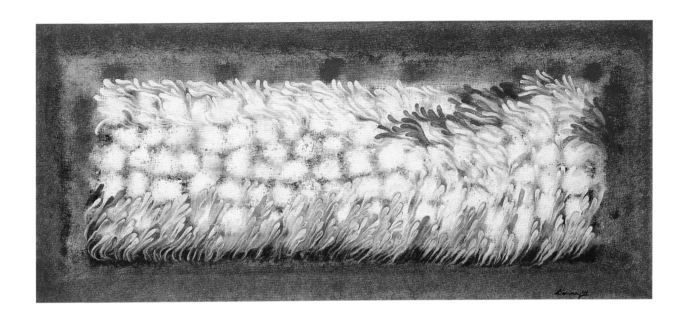

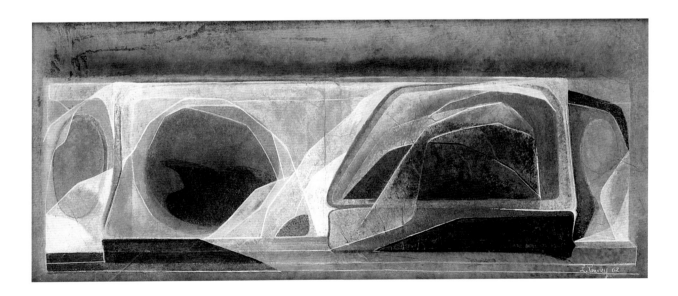

24. *Water Garden*
1964, gouache on Chinese paper, 9½ × 22 in., private collection

25. *Winter Garden*
1962, gouache on Chinese paper, 9½ × 21¾ in., Dr. Allan and Gloria Lobb

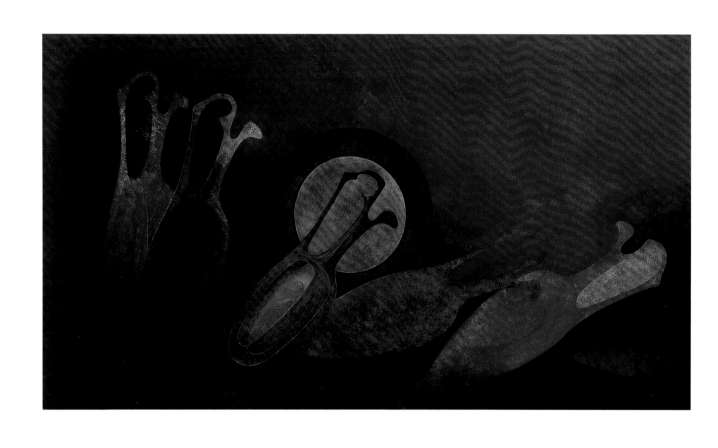

26. *Episode*
1962, gouache on paper, 27 × 47½ in., Museum of Northwest Art, promised gift of Marshall and Helen Hatch

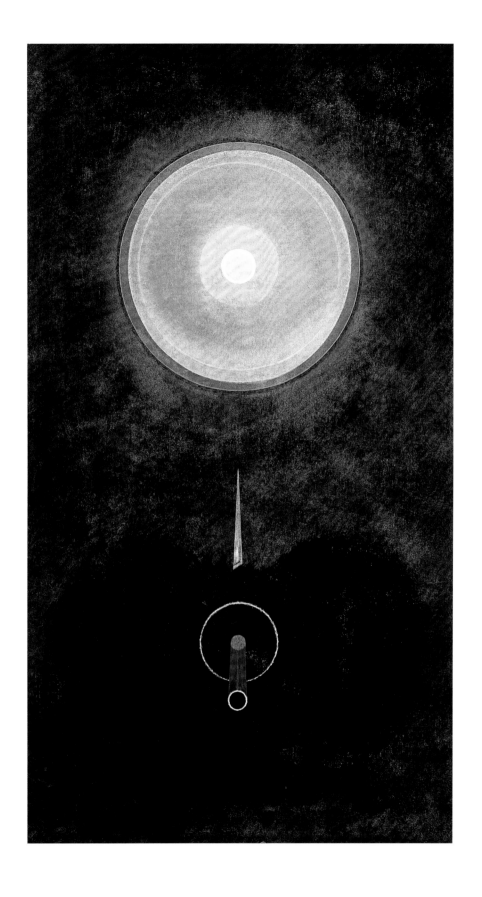

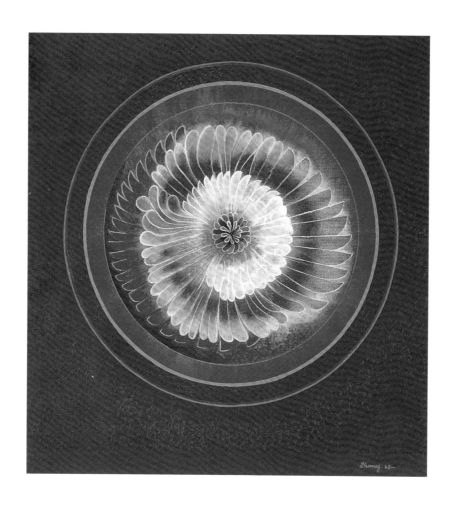

27. *Dualogue* (opposite)
1963, gouache on Chinese paper, 41⅝ × 23½ in., Seattle Art Museum, Eugene Fuller Memorial Collection

28. *Feather-Waterbloom*
1963, gouache on Chinese paper, 12½ × 11½ in., Donald Frothingham

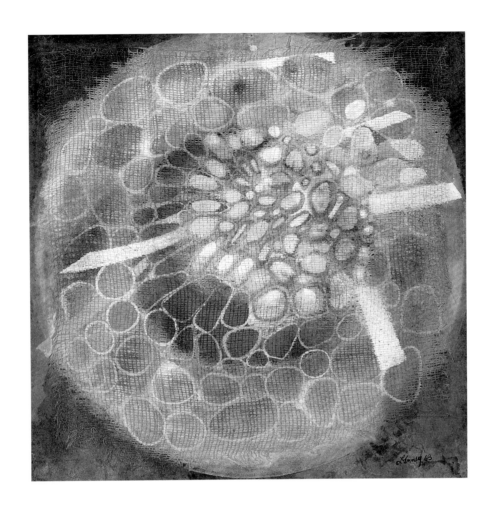

29. *Flowering Blue*
1963, gouache and gauze collage on Chinese paper, 10¼ × 10¼ in., Jan Thompson

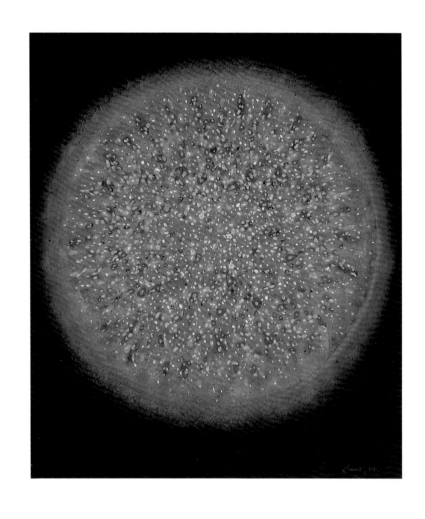

30. *Golden Seed*
1964, gouache on Chinese paper, 11 × 9¾ in., Leo Kenney

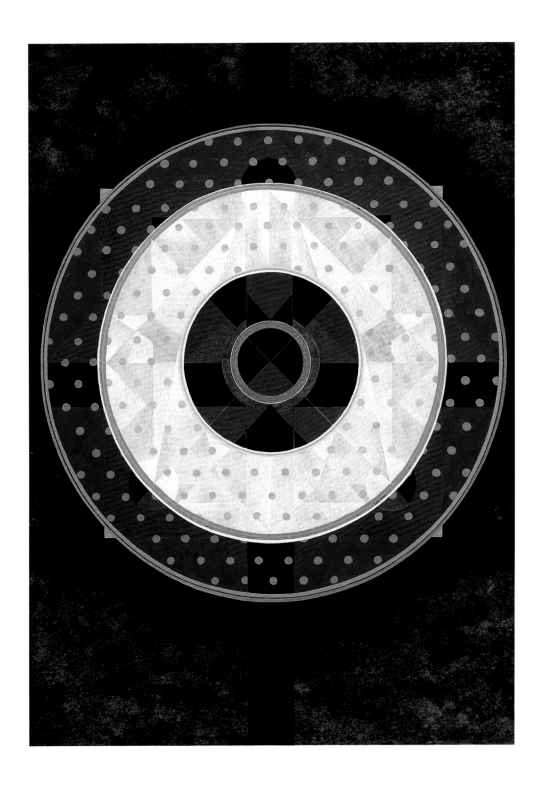

31. *House of the Voice*
1964, gouache on Chinese paper, 23¼ × 17½ in., Jeannie and Charles Gravenkemper

32. *In Situ: Buried Forms* (opposite)
1964, gouache on paper, 34½ × 11½ in., Jeannie and Charles Gravenkemper

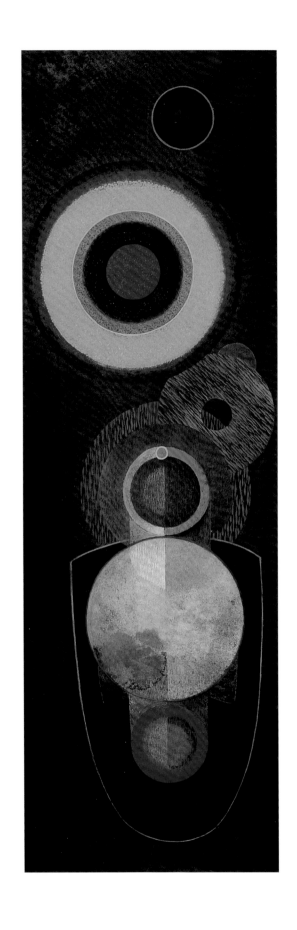

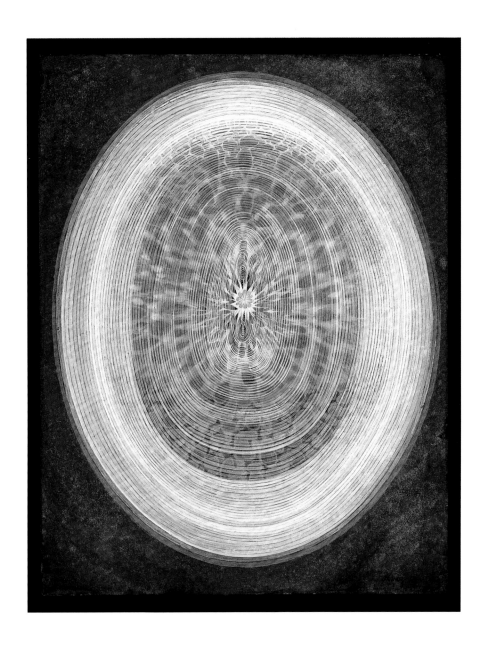

33. Seed and Beyond II
1964, gouache on paper mounted on wood panel, 19¼ × 15 in., Seattle Art Museum, Eugene Fuller Memorial Collection

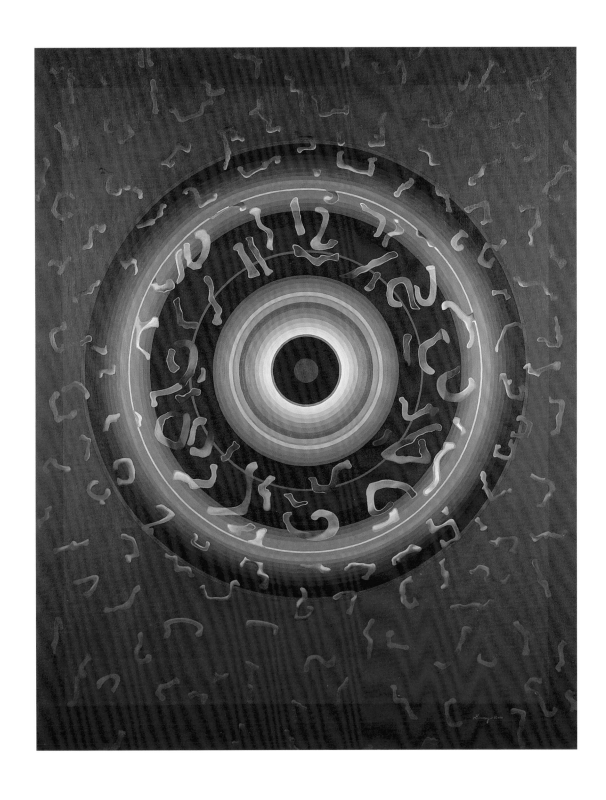

34. *Time Painting: The Formation of Numbers in Time*
1964–66, oil on masonite panel, 45½ × 36 in., Charlotte Macmillan

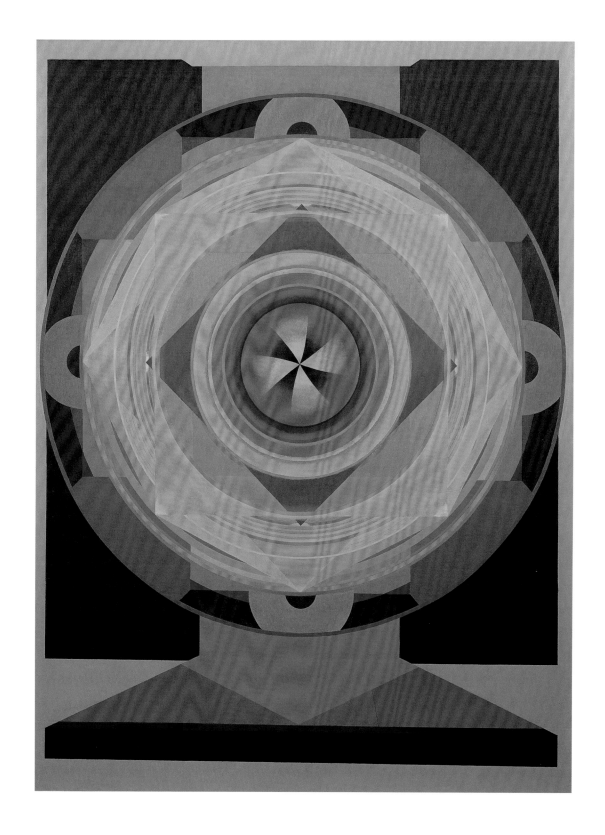

35. *Communicator*
1965, oil on masonite panel, 45⅝ × 34 in., Merch and Alice Pease

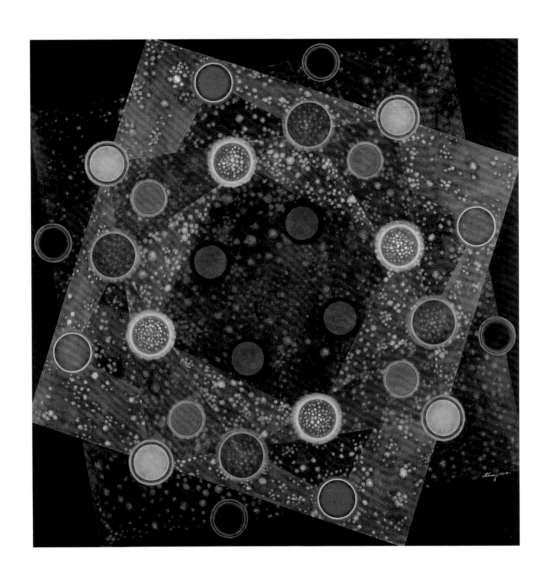

36. *Formation #III: Autumn Warmth*
1965, oil on masonite panel, 40 × 40 in., Dr. and Mrs. John R. Fitzgerald

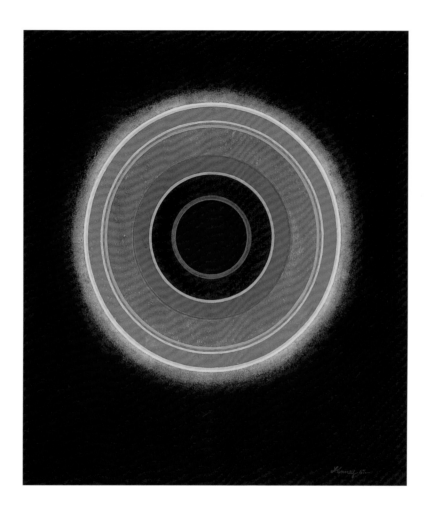

37. *Rapport III*
1967, gouache on Chinese paper, 18 × 16 in., Janet Huston

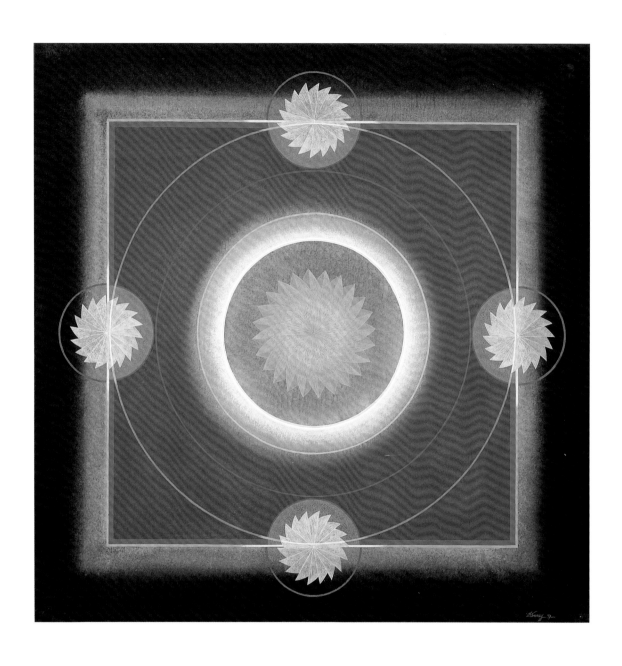

38. *Dream of the Cardinal Points*
1971, gouache on Chinese paper, 27¾ × 27½ in., Museum of Northwest Art, promised gift of Marshall and Helen Hatch

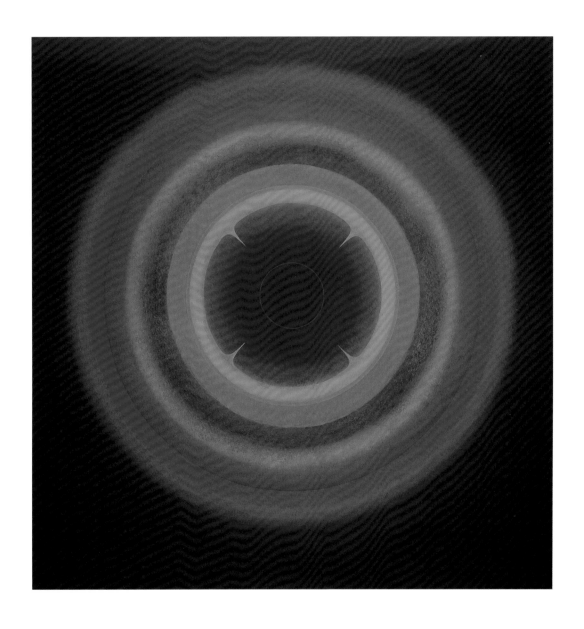

39. *Amaranth*
1966, gouache on Chinese paper, 27½ × 27 in., Museum of Northwest Art, promised gift of Marshall and Helen Hatch

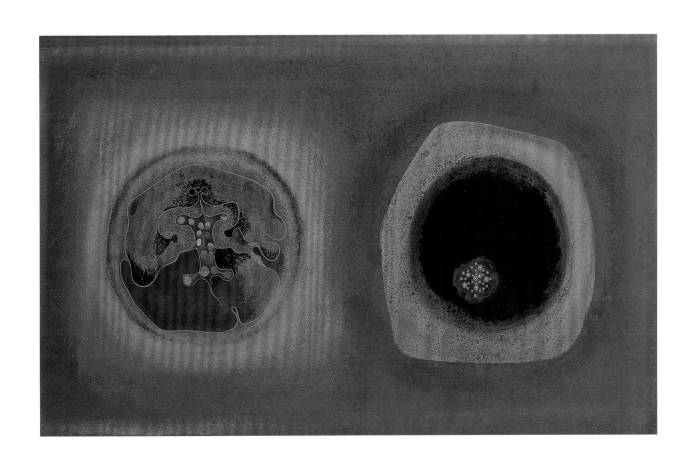

40. *Two Dreaming Forms*
1966, gouache on Chinese paper, 18¾ × 29 in., Blair and Lucy Kirk

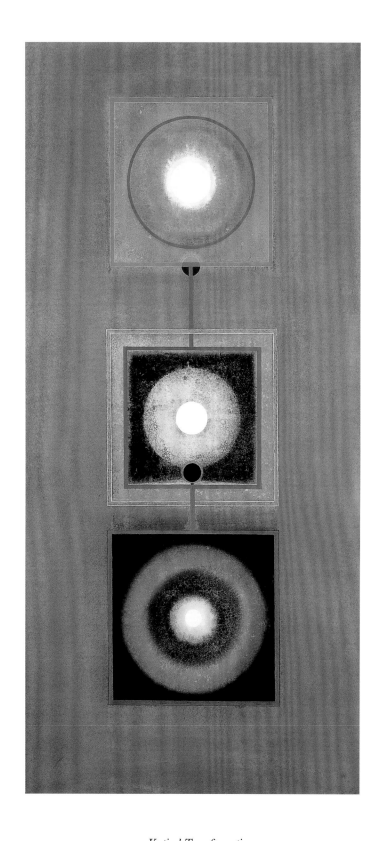

41. *Vertical Transformation*
1966, gouache on Chinese paper, 46 × 22 in., Anne Gould Hauberg

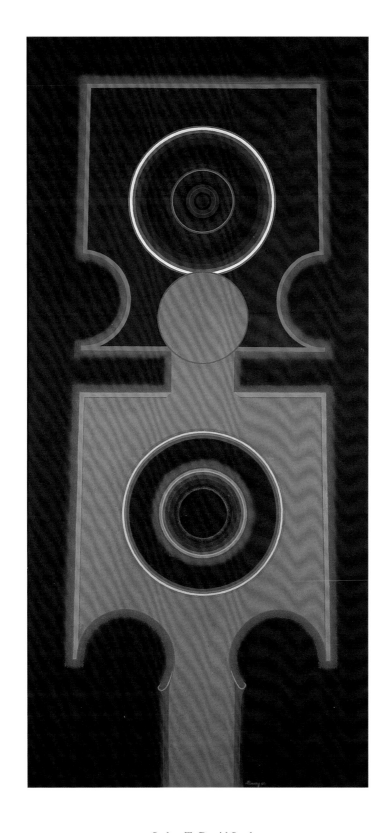

42. *Seeker: To David Stackton*
1967, gouache on Chinese paper, 46 × 22 in., Charlotte Macmillan

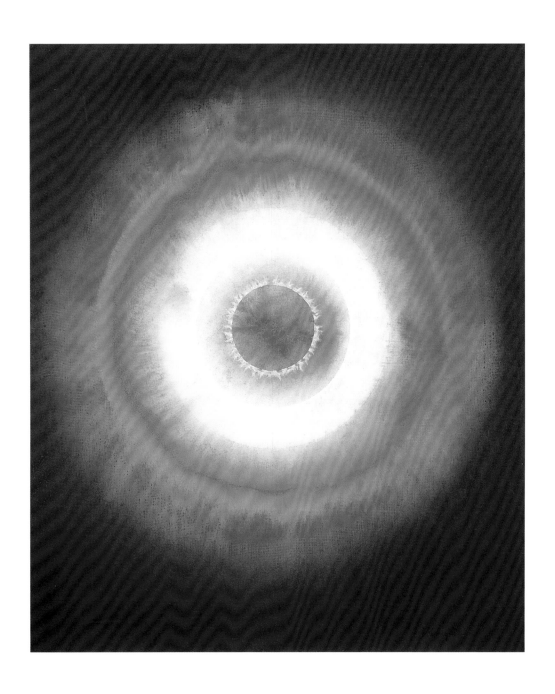

43. *A Breath of Light*
1968, gouache on Chinese paper, 20⅛ × 17⅛ in., Museum of Northwest Art, bequest of Stephen Joseph

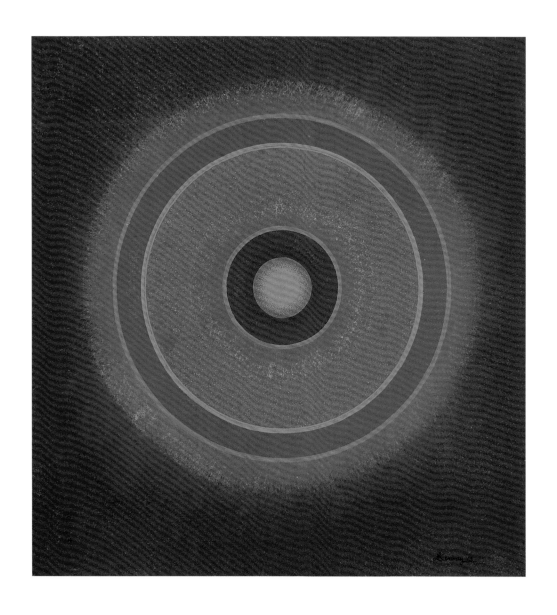

44. *Soft Red*
1968, gouache on Chinese paper, 17 × 16 in., Merch and Alice Pease

65

45. *Seed and Beyond VI*
1969, gouache on Chinese paper, 27¾ × 21¾ in., Caryl Roman

46. *Formation: Salmon and Blue*
1971, gouache on Chinese paper, 11¼ × 10¼ in., Mr. and Mrs. Robert M. Sarkis

47. *Golden Seed*
1971, gouache on Chinese paper, 10¾ × 9¾ in., Merch and Alice Pease

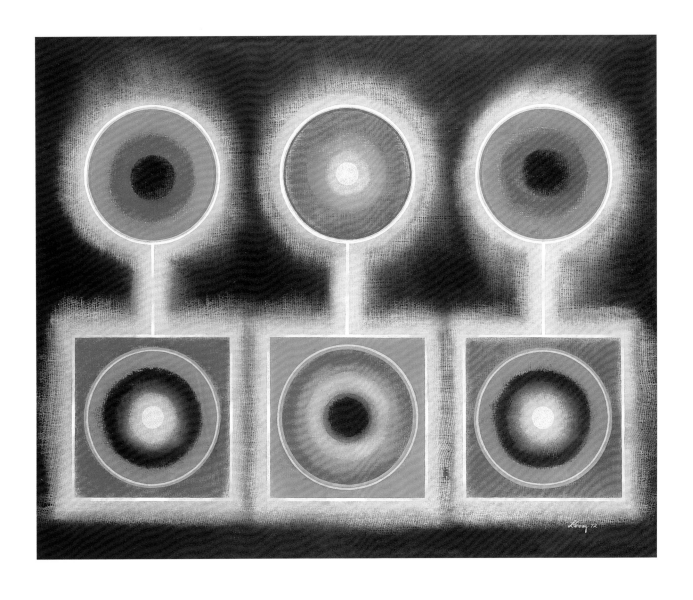

48. *American Night*
1972, gouache on Chinese paper, 22½ × 27¾ in., Alan Fraser Black

49. *Fire Sign* (opposite)
1972, gouache on Chinese paper, 27¾ × 10 in., Caryl Roman

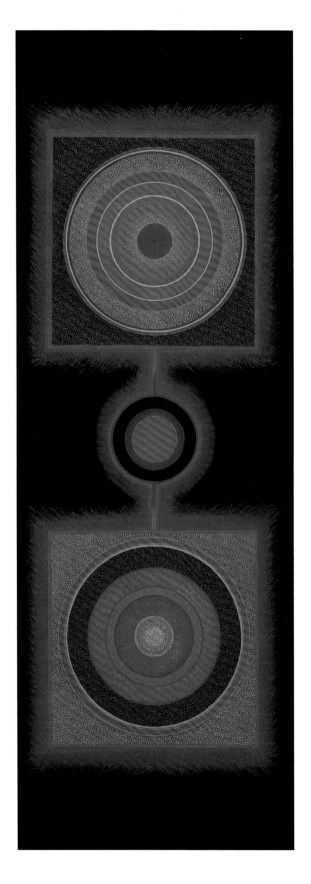

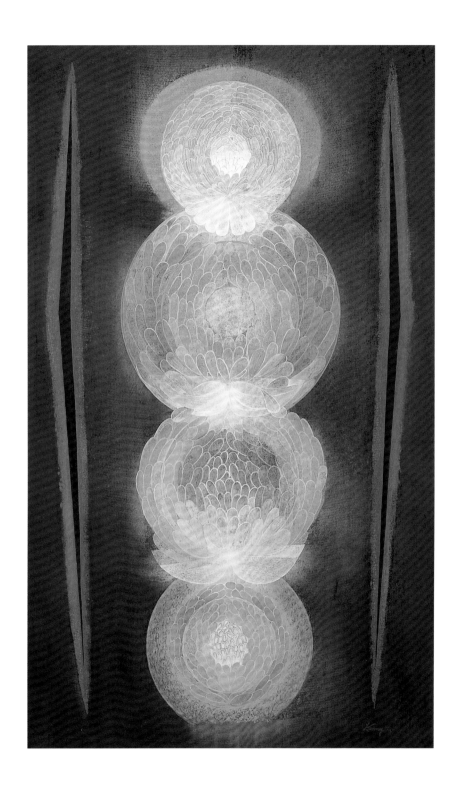

50. *Petal, Wings, and Light*
1972, gouache on Chinese paper, 34 × 23 in., Philip Flash

51. *Vertical Phases: Pendulum* (opposite)
1972, gouache on Chinese paper, 44 × 11¾ in., Dr. and Mrs. Bernard S. Goffe

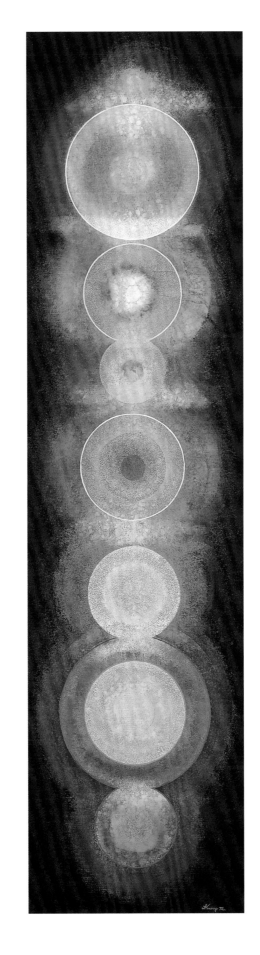

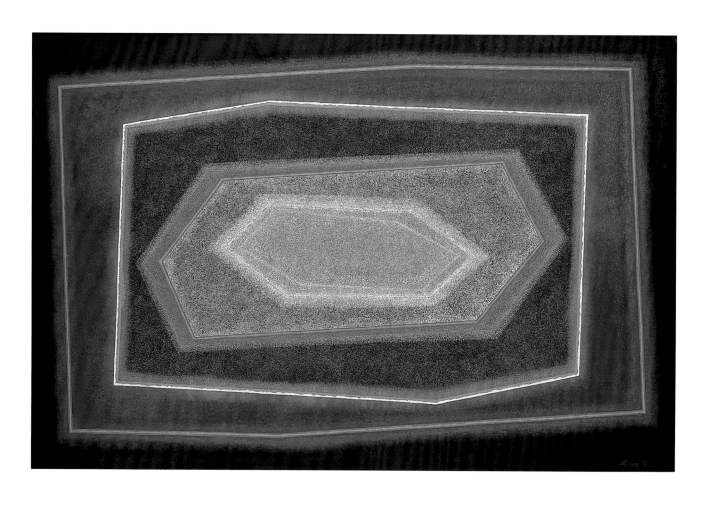

52. *Lake Gemma*
1973, gouache on Chinese paper, 24½ × 37¾ in., Caryl Roman

53. *Seed and Beyond VII* (opposite)
1973, gouache on Chinese paper, 33 × 21¾ in., Caryl Roman

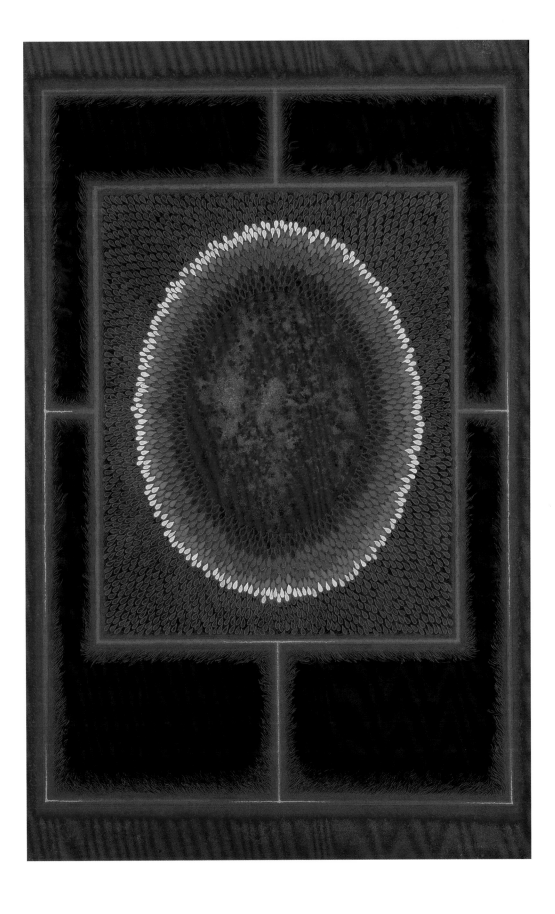

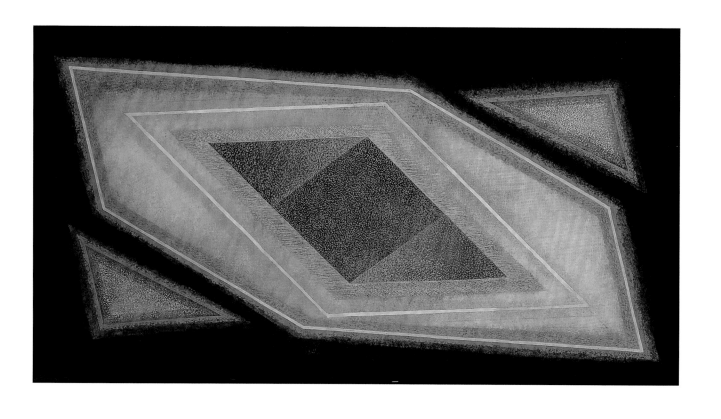

54. *Diamond Lens*
1974, gouache on Chinese paper, 10¾ × 19¾ in., Caryl Roman

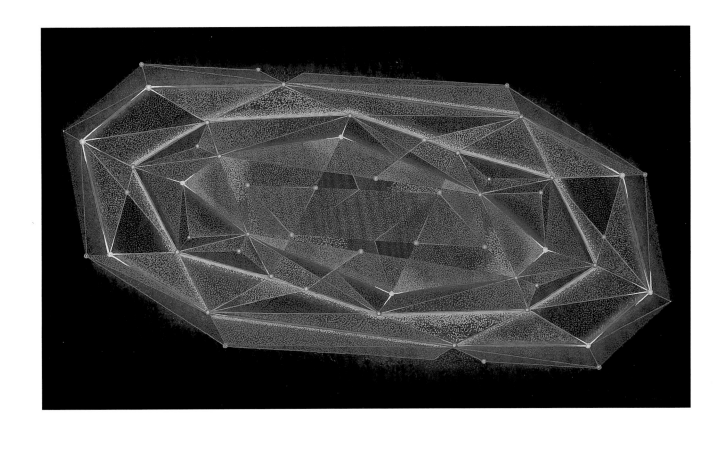

55. *Crystal Ship II*
1975, gouache on Chinese paper, 11½ × 19⅝ in., Blair and Lucy Kirk

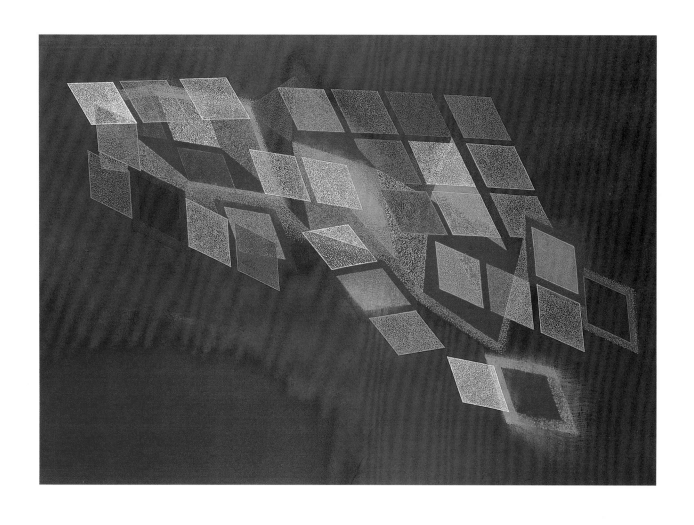

56. *Flight over Red Cloud*
1975, gouache on Chinese paper, 20 × 27¾ in., Marcella Benditt

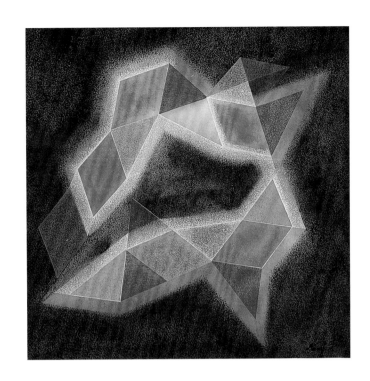

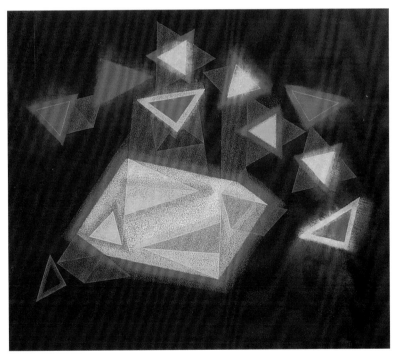

57. *Floating Forms*
1975, gouache on Chinese paper, 13½ × 13½ in., Simon and Carol Ottenberg

58. *Stars in Red Weather*
1975, gouache on Chinese paper, 20½ × 23½ in., Museum of Northwest Art, promised gift of Marshall and Helen Hatch

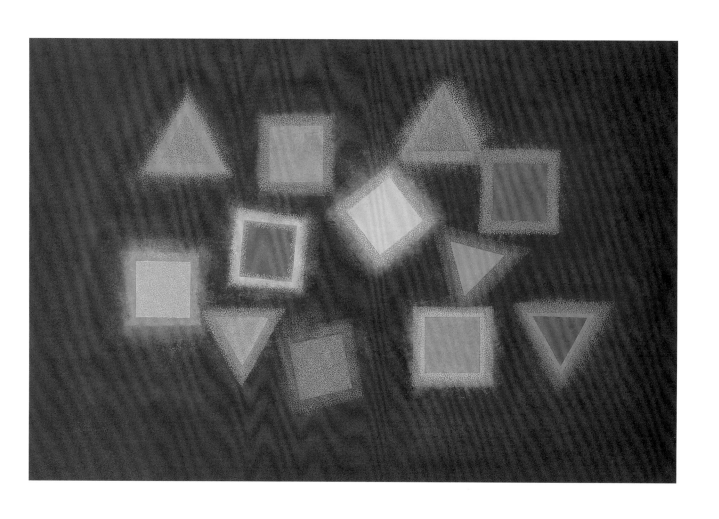

59. *Album*
1976, gouache on Chinese paper, 15½ × 22½ in., Anne Gould Hauberg

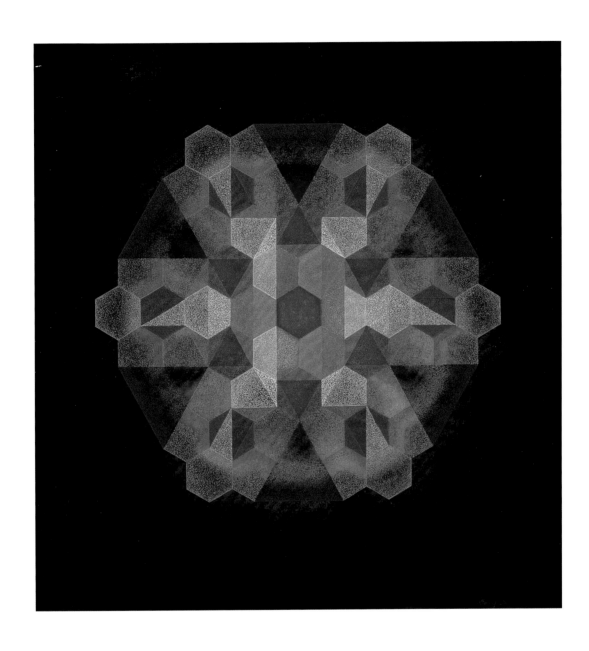

60. *Cyclops Meditation*
1976, gouache on Chinese paper, 25½ × 24½ in., Mr. and Mrs. Robert M. Sarkis

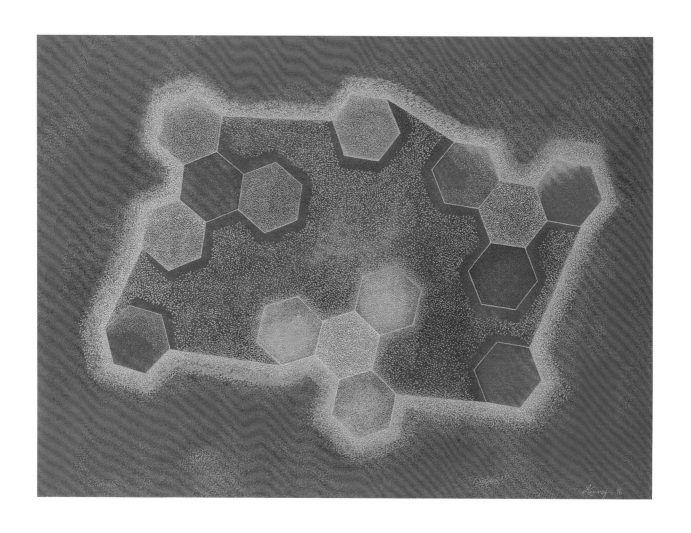

61. *Island in Summer*
1976, gouache on Chinese paper, 15½ × 21¼ in., Anne Clark Holt

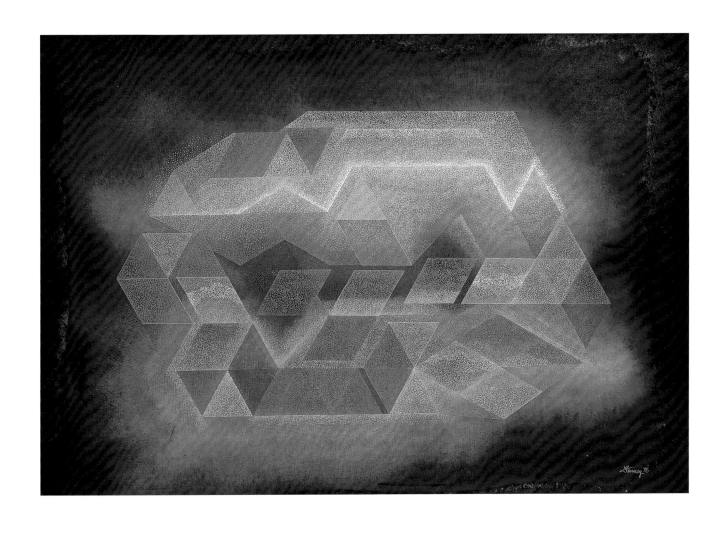

62. *Winter of Artifice*
1976, gouache on Chinese paper, 18¼ × 26⅝ in., Caryl Roman

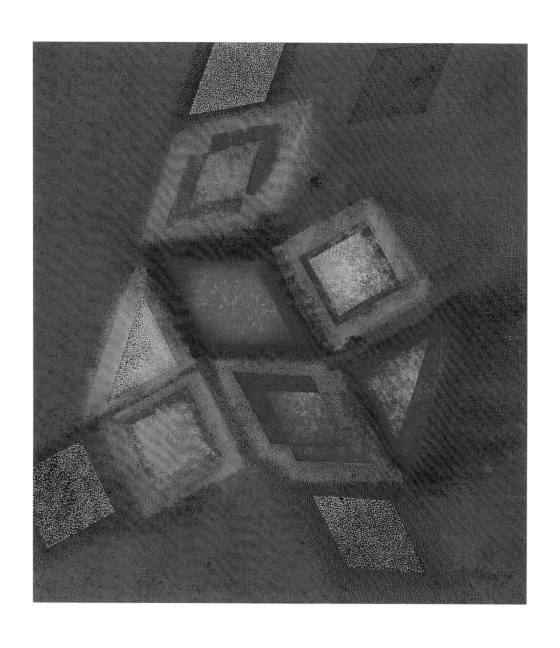

63. *Preceding Spring II*
1977, gouache on Chinese paper, 15 × 14 in., Merch and Alice Pease

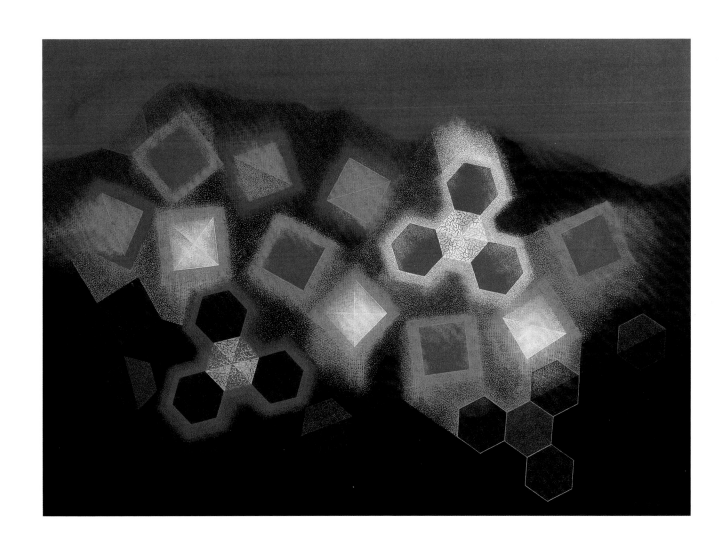

64. *Under February*
1977, gouache on Chinese paper, 20¼ × 28½ in., Dr. and Mrs. Gerald Olch

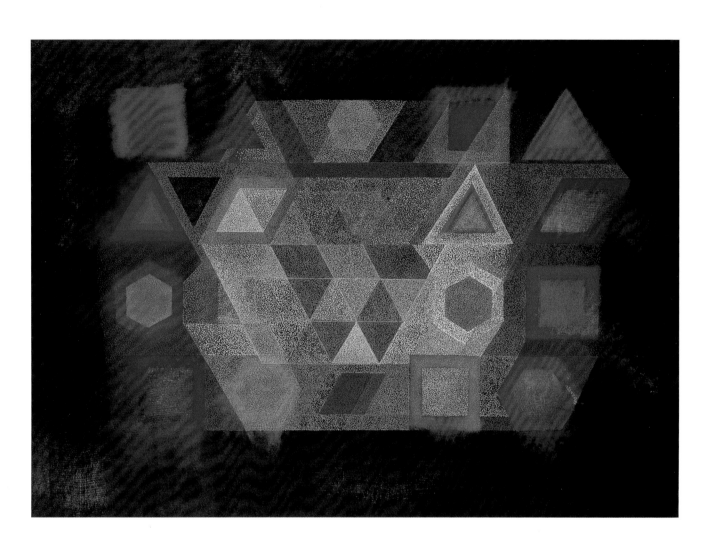

65. *Tableau*

1978, gouache on Chinese paper, 21¼ × 29¼ in., William and Vasiliki Dwyer

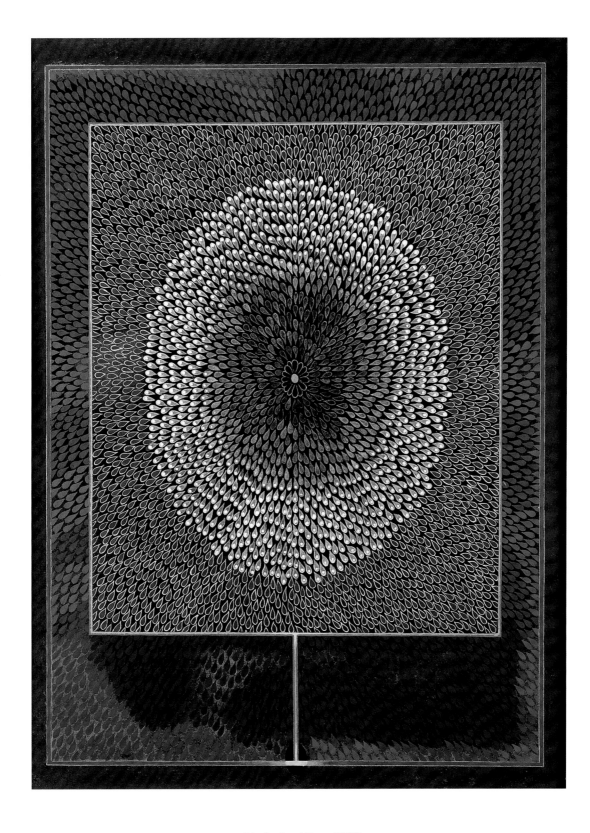

66. *Seed and Beyond VIII*
1981–82, gouache on Chinese paper, 26½ × 19¾ in., Caryl Roman

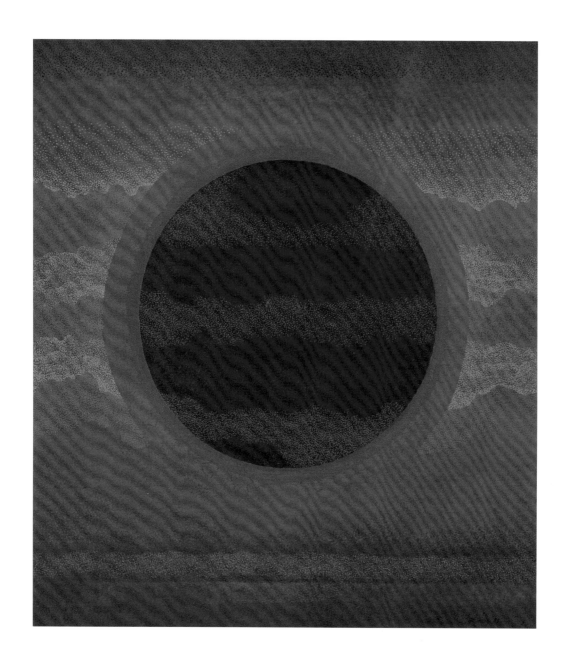

67. *Landscape and Void*
1983, gouache on Chinese paper, 25¾ × 23 in., Museum of Northwest Art, promised gift of Marshall and Helen Hatch

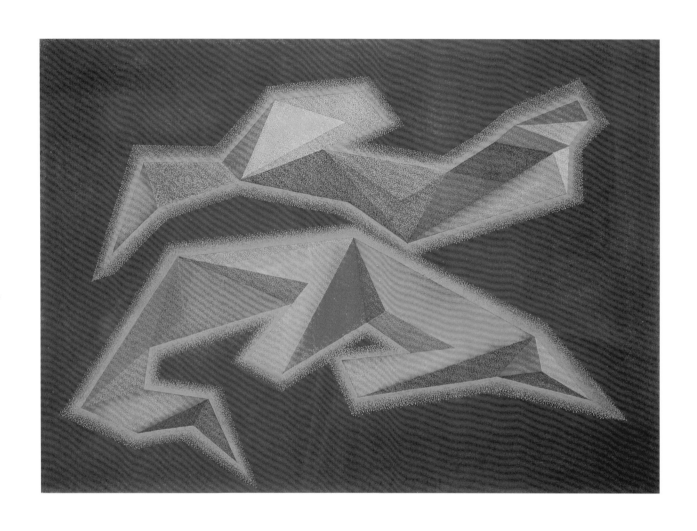

68. *Two Part Invention*
1983, gouache on Chinese paper, 29½ × 37¾ in., Ralph and Shirley Anderson

87

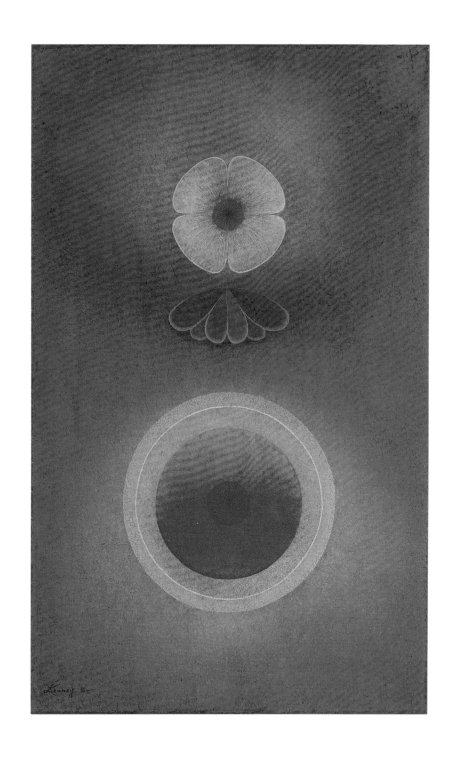

69. *Planet, Leaf and Flower*
1988, gouache on Chinese paper, 16 × 10 in., Carroll and Chuck Benton

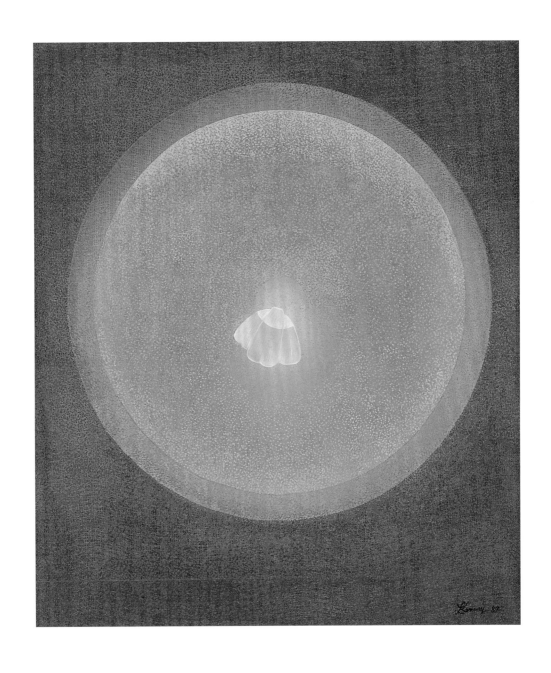

70. *Lunar Moth*
1989, gouache on Chinese paper, 14 × 12 in., Carroll and Chuck Benton

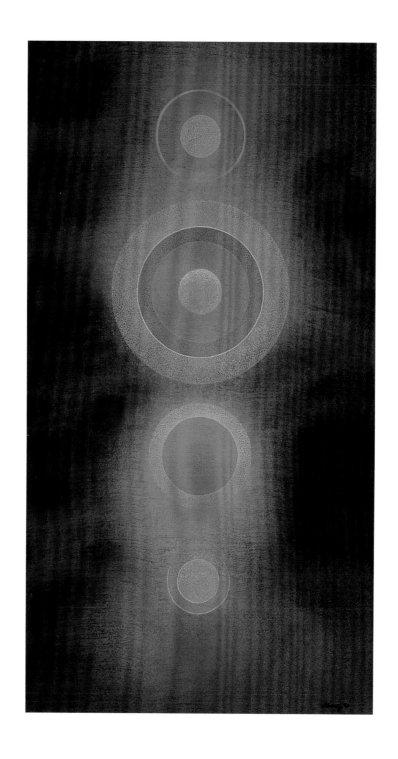

71. *Sightings*
1990, gouache on Chinese paper, 19¾ × 10½ in., Merch and Alice Pease

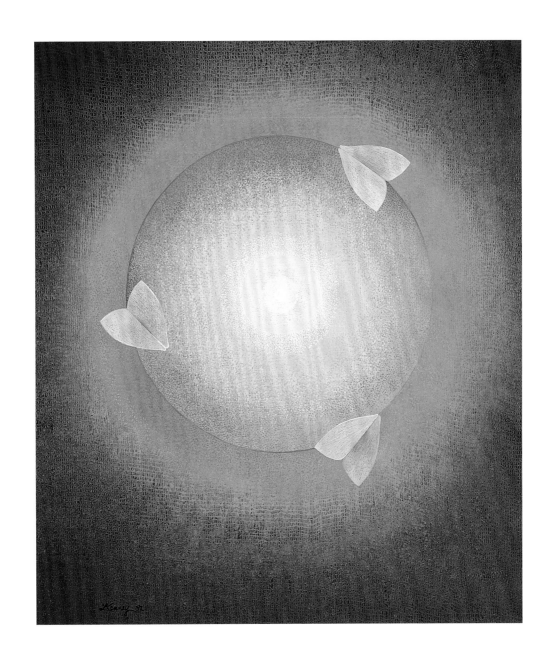

72. *Around a Light II*
1992, gouache on Chinese paper, 15 × 13 in., Mr. and Mrs. Douglas Fleming

Chronology

<div align="center">

Born
Spokane, Washington
March 5, 1925

Education
Self-taught

</div>

Awards

1948 Lowman and Hanford Purchase Prize, Seattle Art Museum,
 Northwest Annual

1965 First prize, 25th Annual Northwest Watercolor Society Exhibition,
 Seattle Art Museum

1967 National Institute of Arts and Letters grant

1968 Pacific Northwest Arts and Crafts Foundation award,
 Seattle Art Museum, Northwest Annual

1980 Betty Bowen Special Recognition Award, Seattle Art Museum

Solo Exhibitions

1944 Little Gallery, Frederick & Nelson, Seattle

 Gallery of Helen Bush School, Seattle

1946 Little Gallery, Frederick & Nelson, Seattle

1949 Seattle Art Museum, Seattle

1953 Gump's Gallery (with painter-sculptor Leona Wood), San Francisco

1954 Ziville Gallery, Hollywood, California

1961 The Arches Gallery, San Francisco

1964 Scott Galleries, Seattle

1968 Willard Gallery, New York

 Richard White Gallery (with sculptor Philip McCracken), Seattle

1970 Richard White Gallery, Seattle

1972 Richard White Gallery, Seattle

1973 Seattle Art Museum (retrospective exhibition), Seattle

 Foster/White Gallery, Seattle

1975 *Early Surrealist Works by Leo Kenney and Morris Graves* (organized by the
 Pacific Northwest Arts Council), Pacific Northwest Arts Center, Seattle

1977 Gallery of Cornish Institute, Seattle

 Foster/White Gallery, Seattle

1979 Foster/White Gallery, Seattle

1996 *Leo Kenney: Geometrics,* Port Angeles Fine Arts Center, Port Angeles,
 Washington

2000 *Celebrating the Mysteries* (retrospective exhibition), Museum of Northwest
 Art, La Conner, Washington

Group Exhibitions

1966 *Twentieth-Century Painting from Washington State Collections,* Washington Gallery of Modern Art, Washington, D.C., and Seattle Art Museum, Seattle

 52nd Annual Exhibition of Northwest Artists, Seattle Art Museum, Seattle

1966–68 *A University Collects: Oregon Pacific Northwest Heritage* (exhibition circulated by the American Federation of Arts)

1967 Awards Recipients of the National Institute of Arts and Letters, American Academy of Arts and Letters, New York

1968 *The West Coast Now,* Portland Art Museum, Portland, Oregon; Seattle Art Museum, Seattle; Los Angeles Municipal Art Gallery, Los Angeles; M. H. de Young Memorial Museum, San Francisco

1971 *The 73rd Western Annual,* Denver Art Museum, Denver

1972 *Northwest Masters,* Festival '72, Seattle Art Museum, Seattle

1974 *Art of the Pacific Northwest: From the 1930s to the Present,* National Collection of Fine Arts, Smithsonian Institution, Washington, D.C.

1978 *Northwest Traditions,* Seattle Art Museum, Seattle

1981 *Artists of Washington,* Washington State Pavilion, Portopia, Kobe, Japan

 Northwest Visionaries, Institute of Contemporary Art, Boston

1982 *Spiritualism in Northwest Art,* Henry Art Gallery, University of Washington, Seattle

 Pacific Northwest Artists and Japan, National Museum of Art, Osaka, Japan

1986 *Northwest Impressions: Works on Paper,* Henry Art Gallery, University of Washington, Seattle

1990 *Views and Visions in the Pacific Northwest,* Seattle Art Museum, Seattle

1994 *Northwest Masters Exhibition,* Foster/White Gallery, Seattle

1997 *10th Anniversary Exhibition,* Port Angeles Fine Arts Center, Port Angeles, Washington

Public Collections

City Art Museum, Saint Louis

Henry Art Gallery, University of Washington, Seattle

Humboldt Arts Council, Eureka, California

Museum of Art, University of Oregon, Eugene

Museum of Northwest Art, La Conner, Washington

Seattle Art Museum, Seattle

Seattle Arts Commission, Seattle

Tacoma Art Museum, Tacoma

Vancouver Art Gallery, Vancouver, British Columbia

Whatcom Museum of History and Art, Bellingham, Washington

Selected Bibliography

1949

Kenneth Callahan. "Novelty Seen in Seattle-ite's Paintings." *Seattle Times,* 1949.

Betty Cornelius. "Seattle Painter in His Studio." *Seattle Times,* 1949.

1953

"Current Art Exhibits." *San Francisco Chronicle,* October 11, 1953. ". . . paintings of Leo Kenney are more symbolic or visionary . . ."

1954

Jules Langsner. Review. *Art News,* January 1954.

1964

Tom Robbins. "The Visual Arts." *Seattle Times,* September 13, 1964. "Sharing a deep affinity with Morris Graves, Kenney's . . . penetrating statements on the mysteries of being are definitely his own."

1965

Tom Robbins. "Local Painters Re-appraised." *Seattle Magazine,* November 1965.

1968

Jean Batie. "Leo Kenney Has NYC Showing." *Seattle Times,* April 1968.

John Canaday. "Show Offerings Range from Albers to Paik." *New York Times,* 1968. "There must be a whole set of sensitivities that flourish better in Seattle than New York."

Sally Hayman. "Is Seattle Ready for Them?" *Seattle Post-Intelligencer,* December 1, 1968.

Sally Hayman. "Pavilion Showcases New Northwest Art." *Seattle Post-Intelligencer,* 1968.

Tom Robbins. "Heir to Tobey and Graves." *Seattle Magazine,* March 1968, 11–12.

Peter Selz with Tom Robbins. "West Coast Report: The Pacific Northwest Today." *Art in America,* November 1968.

Willard Gallery. Exh. cat. April 1968.

1970

John Voorhees. "Kenney Travels in Best Circles." *Seattle Times,* December 7, 1970.

1972

Stephanie Miller. "The Progression of Leo Kenney." *Seattle Post-Intelligencer,* November 26, 1972.

John Voorhees. "Leo Kenney Exhibit Hints at New Direction." *Seattle Times,* November 8, 1972.

1973

Maggie Hawthorn. "Kenney Works Going on Display." *Seattle Post-Intelligencer,* November 1, 1973.

Tom Robbins. *Leo Kenney: An Adventure of the Imagination.* Exh. cat. Seattle: Seattle Art Museum, 1973.

Deloris Tarzan. "Leo Kenney Honored at Art Museum." *Seattle Times,* November 1973.

1974

Martha Kingsbury. "Seattle and Puget Sound—Art of the Pacific Northwest," in *Art of the Pacific Northwest: From the 1930s to the Present.* Smithsonian Institution, National Collection of Fine Arts, Washington, D.C., 1974, 41–92.

1975

R. M. Campbell. "Graves, Kenney Surrealism Efforts at Northwest Art Center." *Seattle Post-Intelligencer,* July 20, 1975.

1977

R. M. Campbell. "A Rare Showing of Leo Kenney." *Seattle Post-Intelligencer,* January 14, 1977.

"In the Galleries." *Seattle Weekly,* January 19–25, 1977. "Kenney's canvases seem to generate their own lustrous life."

Jeanne H. Metzger. "Glowing Kenney." *Everett Herald,* January 20, 1977.

Deloris Tarzan. "Graves, Kenney Share Show with Masters." *Seattle Times,* Arts and Entertainment, January 16, 1977.

1978

Matthew Kangas. "Is Northwest Art Worth All the Fuss?" *Argus,* November 10, 1978.

Martha Kingsbury. *Northwest Traditions.* Exh. cat. Seattle: Seattle Art Museum, 1978.

1979

Deloris Tarzan. ""Kenney, Okada and Geise in Strong Show." *Seattle Times,* May 4, 1979.

1981

Kenneth Baker. "Return to Regionalism, the Northwest Territorial Imperative." *Boston Phoenix,* July 14, 1981.

Charles Giuliana. "Northwest Visionaries at ICA." *Boston Ledger,* July 10–17, 1981.

Stephen S. Prokopoff. *Northwest Visionaries.* Exh. cat. Boston: Institute of Contemporary Art, 1981.

Mark Stevens. "Northwest Visionaries." *Newsweek,* August 3, 1981.

Deloris Tarzan. "Northwest Painting Seen as Visions of 'Land's End,'" *Seattle Times,* 1981.

Robert Taylor. "Northwest Visionaries Endow Works with Power of Magic." *Boston Sunday Globe,* July 12, 1981.

1982

Pacific Northwest Artists and Japan. Exh. cat. Osaka: National Museum of Art, 1982.

James M. Rupp. "Pacific Northwest Art Featured in Osaka." *Seattle Times,* October 17, 1982.

1986

Regina Hackett. "Art Show Looks Good on Paper." *Seattle Post-Intelligencer,* September 30, 1986.

1990

Sheila Farr. "La Conner Show Juxtaposes Art and Artists." *Bellingham Herald,* June 26, 1990.

1996

Deloris Tarzan Ament. "Leo Kenney in Rare Show on Olympic Peninsula." *Seattle Times,* August 18, 1996.

Sheila Farr. "Order and Chaos, Northwest Art: A Rare Survey of Leo Kenney's Colorful, Geometric Paintings." *Seattle Weekly,* September 11, 1996.

Port Angeles Fine Arts Center. *Leo Kenney Geometrics.* Exh. cat. 1996.

Jake Seniuk. "The Cosmic Geometry of Leo Kenney." *On Center,* summer 1996.

Exhibition Checklist

Album, 1976 (plate 59)
Gouache on Chinese paper
15½ × 22½ in.
Anne Gould Hauberg

Amaranth, 1966 (plate 39)
Gouache on Chinese paper
27½ × 27 in.
Museum of Northwest Art, promised
gift of Marshall and Helen Hatch

American Night, 1972 (plate 48)
Gouache on Chinese paper
22½ × 27¾ in.
Alan Fraser Black

April, 1963
Watercolor on paper
26¼ × 21½ in.
Merch and Alice Pease

Around a Light II, 1992 (plate 72)
Gouache on Chinese paper
15 × 13 in.
Mr. and Mrs. Douglas Fleming

Awakening: Homage to Redon, 1964
Gouache on Chinese paper
24 × 19⅛ in.
University of Oregon, Museum of Art,
Virginia Haseltine Collection of Pacific
Northwest Art

Blue Swimmer, 1962 (plate 21)
Gouache on Chinese paper
9⅛ × 18⅜ in.
Jack Kennemur and Jack Strickland

A Breath of Light, 1968 (plate 43)
Gouache on Chinese paper
20⅛ × 17⅛ in.
Museum of Northwest Art, bequest of
Stephen Joseph

Communicator, 1965 (plate 35)
Oil on masonite panel
45⅝ × 34 in.
Merch and Alice Pease

The Crying Man, 1947 (plate 4)
Gouache on paper
17¼ × 18¼ in.
Museum of Northwest Art, promised
gift of Marshall and Helen Hatch

Crystal Ship II, 1975 (plate 55)
Gouache on Chinese paper
11½ × 19⅝ in.
Blair and Lucy Kirk

Cyclops Meditation, 1976 (plate 60)
Gouache on Chinese paper
25½ × 24½ in.
Mr. and Mrs. Robert M. Sarkis

Dancing Forms, 1975
Gouache on Chinese paper
13½ × 13½ in.
H. Lee Williamson

Departure, 1950 (plate 13)
Gouache on paper mounted on board
34½ × 23 in.
Museum of Northwest Art, promised
gift of Marshall and Helen Hatch

Dial of Spring, 1976
Gouache on Chinese paper
27½ × 27¾ in.
Philip and Rosalyn Rourke

Diamond Lens, 1974 (plate 54)
Gouache on Chinese paper
10¾ × 19¾ in.
Caryl Roman

Dream of the Cardinal Points, 1971 (plate 38)
Gouache on Chinese paper
27¾ × 27½ in.
Museum of Northwest Art, promised
gift of Marshall and Helen Hatch

Dualogue, 1963 (plate 27)
Gouache on Chinese paper
41⅝ × 23½ in.
Seattle Art Museum, Eugene Fuller
Memorial Collection

Enchanted Rock, 1946
Tempera on wove paper
16⅛ × 21⅞ in.
Henry Art Gallery, University of Washington,
gift of Zoe Dusanne

Episode, 1962 (plate 26)
Gouache on paper
27 × 47½ in.
Museum of Northwest Art, promised
gift of Marshall and Helen Hatch

Feather-Waterbloom, 1963 (plate 28)
Gouache on Chinese paper
12½ × 11½ in.
Donald Frothingham

Final Movement, 1946 (plate 2)
Gouache and ink on paper
11½ × 21½ in.
Janet Huston

Fire Sign, 1972 (plate 49)
Gouache on Chinese paper
27¾ × 10 in.
Caryl Roman

Flight over Red Cloud, 1975 (plate 56)
Gouache on Chinese paper
20 × 27¾ in.
Marcella Benditt

Floating Forms, 1975 (plate 57)
Gouache on Chinese paper
13½ × 13½ in.
Simon and Carol Ottenberg

Flowering Blue, 1963 (plate 29)
Gouache and gauze collage on Chinese paper
10¼ × 10¼ in.
Jan Thompson

Formation: Golden Promise, 1970
Gouache on Chinese paper
23¾ × 17½ in.
Museum of Northwest Art, promised
gift of Marshall and Helen Hatch

Formation: Salmon and Blue, 1971 (plate 46)
Gouache on Chinese paper
11¼ × 10¼ in.
Mr. and Mrs. Robert M. Sarkis

Formation: Venus Oracle, 1965–66
Oil on masonite panel
44 × 28½ in.
Lucy and Herb Pruzan

Formation #I: Red Expanse, 1965
Oil on masonite panel
36 × 36 in.
University of Oregon, Museum of Art,
Virginia Haseltine Collection of Pacific
Northwest Art

Formation #III: Autumn Warmth, 1965 (plate 36)
Oil on masonite panel
40 × 40 in.
Dr. and Mrs. John R. Fitzgerald

Golden Seed, 1964 (plate 30)
Gouache on Chinese paper
11 × 9¾ in.
Leo Kenney

Golden Seed, 1971 (plate 47)
Gouache on Chinese paper
10¾ × 9¾ in.
Merch and Alice Pease

Grey Sleeper, 1975
Gouache on Chinese paper
24¼ × 37¼ in.
Bank of America Art Collection

Heavenly Lens, 1963
Tempera and gauze on paper
13¾ × 13¾ in.
Museum of Northwest Art, gift of John
Hauberg and Anne Gould Hauberg

House of the Voice, 1964 (plate 31)
Gouache on Chinese paper
23¼ × 17½ in.
Jeannie and Charles Gravenkemper

Images, 1947 (plate 5)
Gouache and ink on Chinese paper
10 × 21¾ in.
Seattle Art Museum, gift of
William B. Staadecker

Inception of Magic, 1945 (plate 1)
Egg tempera on masonite panel
35½ × 23⅝ in.
Seattle Art Museum, Eugene Fuller
Memorial Collection

In Situ: Buried Forms, 1964 (plate 32)
Gouache on paper
34½ × 11½ in.
Jeannie and Charles Gravenkemper

Island in Summer, 1976 (plate 61)
Gouache on Chinese paper
15½ × 21¼ in.
Anne Clark Holt

Journal of Winter, 1947 (plate 6)
Ink, watercolor, and gouache on paper
10¾ × 9¾ in.
Caryl Roman

Lake Gemma, 1973 (plate 52)
Gouache on Chinese paper
24½ × 37¾ in.
Caryl Roman

Landscape and Void, 1983 (plate 67)
Gouache on Chinese paper
25¾ × 23 in.
Museum of Northwest Art, promised
gift of Marshall and Helen Hatch

Lunar Moth, 1989 (plate 70)
Gouache on Chinese paper
14 × 12 in.
Carroll and Chuck Benton

Metamorphosis, 1948 (plate 7)
Gouache on Chinese paper
9¾ × 23¼ in.
Museum of Northwest Art, promised
gift of Marshall and Helen Hatch

Night Swimmer II, 1954 (plate 22)
Gouache on paper
18¾ × 24¾ in.
Museum of Northwest Art, promised
gift of Marshall and Helen Hatch

Night Swimmer III, 1962 (plate 23)
Gouache and black ink on Chinese paper
27 × 50 in.
Jack Kennemur and Jack Strickland

Northern Image: Muse III, 1948 (plate 8)
Oil on canvas
29⅝ × 19½ in.
Seattle Art Museum, Eugene Fuller
Memorial Collection

Offering of Seed II, 1953 (plate 15)
Gouache on Chinese paper
18¾ × 39¼ in.
Caryl Roman

Petal, Wings, and Light, 1972 (plate 50)
Gouache on Chinese paper
34 × 23 in.
Philip Flash

Phases, 1968
Gouache on Chinese paper
26 × 20 in.
Private collection

Planet, Leaf and Flower, 1988 (plate 69)
Gouache on Chinese paper
16 × 10 in.
Carroll and Chuck Benton

Preceding Spring II, 1977 (plate 63)
Gouache on Chinese paper
15 × 14 in.
Merch and Alice Pease

Protected Grail, 1948 (plate 9)
Gouache on paper
15½ × 12 in.
Merch and Alice Pease

Protected Sign, 1967
Gouache on Chinese paper
27½ × 26 in.
Paul Owen Mehner

Rapport III, 1967 (plate 37)
Gouache on Chinese paper
18 × 16 in.
Janet Huston

Reclining Dreamer, 1946 (plate 3)
Gouache and pencil on paper
11½ × 15⅝ in.
John D. McLauchlan, courtesy of
Martin-Zambito Fine Art

Relic, 1963 (plate 19)
Gouache and gauze collage on Chinese paper
27½ × 27 in.
Mary Randlett

Relic of the Sun, 1961 (plate 18)
Oil on linen
52 × 32 in.
Merch and Alice Pease

Reliquary Flower, 1953 (plate 16)
Gouache and gold leaf on Chinese paper
23 × 18½ in.
Museum of Northwest Art, promised
gift of Marshall and Helen Hatch

Riverworld, 1963
Gouache on Chinese paper
27⅝ × 47½ in.
Richard Levy

Seed and Beyond II, 1964 (plate 33)
Gouache on paper mounted on wood panel
19¼ × 15 in.
Seattle Art Museum, Eugene Fuller
Memorial Collection

Seed and Beyond VI, 1969 (plate 45)
Gouache on Chinese paper
27¾ × 21¾ in.
Caryl Roman

Seed and Beyond VII, 1973 (plate 53)
Gouache on Chinese paper
33 × 21¾ in.
Caryl Roman

Seed and Beyond VIII, 1981–82 (plate 66)
Gouache on Chinese paper
26½ × 19¾ in.
Caryl Roman

Seeker: To David Stackton, 1967 (plate 42)
Gouache on Chinese paper
46 × 22 in.
Charlotte Macmillan

Sightings, 1990 (plate 71)
Gouache on Chinese paper
19¾ × 10½ in.
Merch and Alice Pease

Sleep of the Dove, 1961
Oil on linen
20 × 16 in.
Jack Kennemur and Jack Strickland

Small Sacrifice, 1949 (plate 11)
Gouache and ink on paper
10⅛ × 13⅝ in.
Museum of Northwest Art, promised
gift of Marshall and Helen Hatch

Soft Red, 1968 (plate 44)
Gouache on Chinese paper
17 × 16 in.
Merch and Alice Pease

Stars in Red Weather, 1975 (plate 58)
Gouache on Chinese paper
20½ × 23½ in.
Museum of Northwest Art, promised
gift of Marshall and Helen Hatch

Summer Sign, 1970
Gouache on Chinese paper
24 × 21 in.
William and Vasiliki Dwyer

Tableau, 1978 (plate 65)
Gouache on Chinese paper
21¼ × 29¼ in.
William and Vasiliki Dwyer

Third Offering, 1948 (plate 10)
Oil on canvas
41¼ × 25⅜ in.
Seattle Art Museum, Lowman and
Hanford Purchase Prize

*Time Painting: The Formation of Numbers
in Time*, 1964–66 (plate 34)
Oil on masonite panel
45½ × 36 in.
Charlotte Macmillan

Two Dreaming Forms, 1966 (plate 40)
Gouache on Chinese paper
18¾ × 29 in.
Blair and Lucy Kirk

Two Islands, 1974
Gouache on Chinese paper
15⅛ × 24½ in.
Safeco Collection

Two Part Invention, 1983 (plate 68)
Gouache on Chinese paper
29½ × 37¾ in.
Ralph and Shirley Anderson

Under February, 1977 (plate 64)
Gouache on Chinese paper
20¼ × 28½ in.
Dr. and Mrs. Gerald Olch

Vertical Phases: Pendulum, 1972 (plate 51)
Gouache on Chinese paper
44 × 11¾ in.
Dr. and Mrs. Bernard S. Goffe

Vertical Transformation, 1966 (plate 41)
Gouache on Chinese paper
46 × 22 in.
Anne Gould Hauberg

Voyage for Two, 1953 (plate 20)
Gouache on Chinese paper
19¼ × 23 in.
Seattle Art Museum, gift of the artist

Voyage on an Inner Sea II, 1952 (plate 14)
Gouache and gold leaf on paper
9½ × 20 in.
Jack Kennemur and Jack Strickland

Voyage on an Inner Sea III, 1953 (plate 17)
Gouache on Chinese paper
19½ × 31¼ in.
Museum of Northwest Art, promised
gift of Marshall and Helen Hatch

Water Garden, 1964 (plate 24)
Gouache on Chinese paper
9½ × 22 in.
Private collection

Winter and the Fire, 1949 (plate 12)
Gouache on paper
10⅛ × 13⅝ in.
Museum of Northwest Art, promised
gift of Marshall and Helen Hatch

Winter Architecture, 1967
Gouache on Chinese paper
47 × 28 in.
Jeannie and Charles Gravenkemper

Winter Garden, 1962 (plate 25)
Gouache on Chinese paper
9½ × 21¾ in.
Dr. Allan and Gloria Lobb

Winter of Artifice, 1976 (plate 62)
Gouache on Chinese paper
18¼ × 26⅝ in.
Caryl Roman

Index of Works Illustrated

Sponsors

Our thanks to the following individuals and organizations
for their generous support of this catalog and exhibition.

Richard and Constance Albrecht

Nancy Alvord

Betty Black

Tim and Gail Bruce

Paulette and Ralph Bufano

Susan and Gerry Christensen

Nancy and Larry Erickson

Wallie and Mary Ann Funk

Jeannie and Charles Gravenkemper

Marshall Hatch

Bill and Susan Henry

Vern and Jerry Jackson

Elliott and Vicki Johnson

Gretchen and Curt McCauley

Philip and Anne McCracken

Alice and Bruno Meyer

Judi and Harry Mullikin

Leslie and Steven Nordtvedt

Osberg Family Trust

Paul Allen Foundation for the Arts

Merch and Alice Pease

Charles Stavig

Madelyn and Frank Thomas

Washington State Arts Commission

Washington Women's Foundation

Gordon Woodside/John Braseth Gallery